John Moores Painting Prize 2012

Walker
Art Gallery

National Museums Liverpool

IN PARTNERSHI ... POOL EXHIBITION TRUST

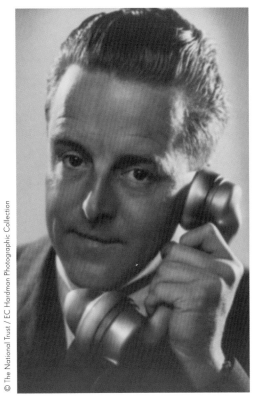

John Moores, 1933. Photograph in the collection of the Walker Art Gallery.

In 1957 John Moores (1896-1993) sponsored a competition for contemporary artists at Liverpool's Walker Art Gallery, with the intention of showcasing the best of new British painting.

The exhibition's main aims, stated in the first catalogue, were:

'To give Merseyside the chance to see an exhibition of painting and sculpture embracing the best and most vital work being done today throughout the country' and 'to encourage contemporary artists, particularly the young and progressive.'

The John Moores Painting Prize has since been held almost every two years. It has become one of the most familiar events in the British art world and forms an important part of the Liverpool Biennial, the UK's Biennial of Contemporary Art.

This year brings the 27th exhibition since 1957, the John Moores Painting Prize 2012, and celebrates the second John Moores Painting Prize China in Shanghai.

Contents

Foreword

Every two years the character of the Walker Art Gallery visibly alters when it acts as the stage for the John Moores Exhibition and the prestigious John Moores Painting Prize. The first exhibition, which took place in 1957, was the result of the initiative of Sir John Moores, who wished to provide a platform for emerging artists and to bring the best of contemporary art to Liverpool. The resulting exhibitions have, year on year, played a pivotal role in promoting the expression of British art. The present popularity of the exhibition both with artists and the public, the discussion that surrounds the chosen works and the media attention that follows it, all demonstrate a healthy interest in British art today. The ensuing assessments of painting in the UK are always thought-provoking but the ongoing profile of the Prize is perhaps conclusion in itself. That the Walker should be central to this debate is a much loved facet of the Gallery's broad-ranging character.

The Walker has, since the early days, regularly acquired works, including many of the prizewinners, from the exhibitions. The legacy of this important art event is not just the revitalised energy that it instills in the Gallery every two years, but a modern and contemporary art collection of outstanding quality in which painting is the core. Hearing younger artists today talk of their visits as students to the Walker, where they had the opportunity to admire works by David Hockney, Jack Smith and Mary Martin amongst others, is clear testament to the impact of the Prize. That the works selected for the John Moores can be seen in the Gallery against the history of painting from the early Renaissance onwards gives the event even more depth.

This year the challenging task of selecting works for the show, and the prizewinners, fell to Fiona Banner (Artist), Iwona Blazwick OBE (Director, Whitechapel Gallery), Angela de la Cruz (Artist), George Shaw (Artist) and Alan Yentob OBE (Creative Director, BBC). We are extremely grateful to them all for their enthusiasm and considered judgement. We also thank them for their positive responses to the many requests for media interviews, filming and catalogue contributions. We would also like to express our gratitude to Sir Peter Blake who has become the first patron of the John Moores Painting Prize. As someone

for whom the Prize and the Walker hold special significance, his advocacy and support is invaluable.

This year also marks the second occasion of the John Moores Painting Prize China, which was held at the Art Museum of the Shanghai Oil Painting and Sculpture Institute from 20 June to 18 July. The jurors were Lewis Biggs (Artistic Director), Michael Craig-Martin (Artist, Art Educator), Tony Bevan (Artist), Yu Hong (Artist), Liu Xiaodong (Artist) and Ding Yi (Artist). The five prizewinning paintings from China are shown in the Walker alongside the UK exhibitors, and presented in this catalogue. We would like to thank Wang DaWei (Dean, Shanghai University, Fine Arts College, and Vice Chairman, Shanghai Artists Association) and Lewis Biggs for their written contributions, and Ling Min (Director of Overseas Arts Projects, Shanghai University, Fine Arts College), who played an important role in the smooth running of this project.

The British John Moores Painting Prize is once more a major part of the Liverpool Biennial, the UK's Biennial of Contemporary Art. We are grateful to Sally Tallant, Artistic Director and CEO of the Liverpool Biennial, and all her team for promoting the Prize within the context of this exciting and important festival. The exhibition this year features 62 works from an original submission of 3,090 entries. All the selected artists should regard themselves as having star roles in a very significant and long-running show.

The talented contribution of all participants advances Sir John Moores' original purpose to present the best of emerging contemporary art and artists in Liverpool. Moreover, many people from outside the city now come to the Walker to enjoy the show. We hope that you too will enjoy what is, quite rightly, one of the major events in the UK's artistic calendar.

Lady Grantchester
John Moores Liverpool Exhibition Trust

Sandra Penketh
Director of Art Galleries,
National Museums Liverpool

The jury

Fiona Banner
Artist

Iwona Blazwick OBE
Director, Whitechapel Gallery

Angela de la Cruz
Artist

George Shaw
Artist

Alan Yentob OBE
Creative Director, BBC

Fiona Banner

Fiona Banner is an artist who lives and works in London. She was shortlisted for the Turner Prize in 2002 and her installation *Harrier and Jaguar* was at Tate Britain in 2010. In 2012 she worked with David Kohn Architects to realise the *Roi des Belges*, a one-bedroom building based on the boat that Joseph Conrad captained up the Congo in 1890, a journey echoed in his most famous work *Heart of Darkness*. Here, Banner staged the world premiere performance of Orson Welles' unrealised film script *Heart of Darkness*. The room is installed atop the Queen Elizabeth Hall at London's Southbank.

Banner has exhibited widely in Europe and America. Her work is represented in many collections in the UK and abroad. In 2013 she is the subject of a major mid-career survey at MAC/VAL in Paris.

Much of Fiona Banner's work stems from her fascination with the near impossibility of containing action and time in a language. Her 'wordscapes' or 'still-films' take the form of blow-by-blow accounts, written in her own words, of feature films or sequences of events. Her practice encompasses sculpture, drawing and publishing. Underlying her art is an interest in language as a form of communication and, in turn, the transference of language, or of speech, into a purely visual form or register.

Books are central to her practice and in 1997 she founded The Vanity Press, through which she has published her own works including *The Nam* (1997), *All The World's Fighter Planes* (2004 / 2006), *The Bastard Word* (2007) and *ISBN 978-1-907118-99-9* (2010).

Iwona Blazwick

Iwona Blazwick lives and works in London, where she is Director of the Whitechapel Gallery.

A writer, curator and broadcaster, she was Director of Exhibitions at London's ICA from 1987 until 1992. From 1993 until 1997 she worked as an Independent Curator in Europe and Japan, and was also a Commissioning Editor at Phaidon Press. In 1997 she joined Tate Modern as art programme curator and subsequently became Head of Exhibitions and Displays. Prior to the opening of Tate Modern in 2000, she worked on devising the display strategy for the Tate's 20th-century collection and the future exhibitions programme. She has been Director of the Whitechapel Gallery since 2001.

Iwona Blazwick was visiting tutor at the Royal College of Art and teaches occasionally at Goldsmiths School of Art, Central Saint Martins, Middlesex University, the Slade School and Sotheby's MA Course. In addition, she has taught at academies in Hamburg, Malmo and Vienna.

Her writings include numerous catalogues and monographs on contemporary art, artists and institutions. She was editor of the *Tate Modern Handbook* and *Century City* and is Series Editor of *Documents of Contemporary Art* (Whitechapel/MIT).

Iwona Blazwick has been a judge for several awards including the *Turner Prize* and the Venice Biennale Golden Lion Award, and chairs the jury of the ongoing MaxMara Art Prize for Women.

In 2008, Iwona Blazwick was awarded an OBE.

© Ione Saizar

Angela de la Cruz

At first glance, de la Cruz's paintings appear to have been vandalized or flagrantly abused. Mangled stretchers, slashed canvases, twisted and violated, are hung on the wall like macabre trophies, and yet it is this deliberate and systematic desecration of the canvases, which informs the end result. Emotionally raw, yet canny and sharply ironic, de la Cruz confronts the 'problem' with painting by incorporating its very destruction into the work itself. *"The moment I cut through the canvas I get rid of the grandiosity of painting."* Violent, unapologetic and often darkly humorous, her work unabashedly exposes a visceral emotionalism, breaking the barriers of the established norms of painting. Implicit is the sense that a scene of frenetic violent activity has just taken place leaving in its wake the strangely paradoxical feeling of spent energy and a sense of calm.

Angela de la Cruz was born in La Coruña, Spain, in 1965, where she studied philosophy at the University of Santiago de Compostela. In the late eighties she moved to London where she studied at Chelsea College of Art and later at Goldsmiths College and The Slade School of Art. She has exhibited in galleries all over the world including in *After*, her first solo exhibition in the UK at Camden Arts Centre in April 2010. In May 2010 she was nominated for the *Turner Prize.*

Angela de la Cruz lives and works in London.

George Shaw

George Shaw was born in 1966 in Coventry. After studying Fine Art at Sheffield Polytechnic he gained an MA in painting at the Royal College of Art in London. He is based in Ilfracombe, North Devon. His highly detailed, realist paintings celebrate the mundane suburban landscape, and he works from photographs taken of and around his childhood home on the Tile Hill Estate, Coventry. His favoured medium is Humbrol enamel paints, which lend his work a unique appearance as they are more commonly used to paint Airfix models. George Shaw has exhibited widely nationally and internationally since the early 1990s and his work is represented in several public collections.

He was a prizewinner in *John Moores 21*, 1999, and in 2011 was nominated for the *Turner Prize* for his solo exhibition *The Sly and Unseen Day* at the BALTIC Centre for Contemporary Art, Gateshead. His work will feature in the major forthcoming exhibition *Force of Nature: Picturing Ruskin's Landscape* at Sheffield's Millennium Gallery and in a solo show at the Douglas Hyde Gallery, Dublin in 2013.

Alan Yentob

Alan Yentob is the Creative Director of the BBC and Editor and Presenter of the *Imagine* programme.

A celebrated and award-winning programme maker, Alan quickly came to personify the creative spirit of the BBC. He joined as a general trainee in 1968, taking his first job in the World Service.

From 1973 to 1975 he was a producer/director with *Omnibus*, where his films famously included *Cracked Actor: David Bowie*. In 1978 he created the mould-breaking arts series *Arena*, and was Editor until 1985. During this time *Arena* produced influential programmes including *The Private Life of the Ford Cortina*, *My Way* and *The Orson Welles Story*.

In 1985 Alan became Head of Music and Arts and stayed in the post until 1988 when he was appointed Controller of BBC Two. Under his five-year stewardship BBC Two was revitalised and introduced many innovations in programming including *The Late Show*, *Have I Got News For You?*, *Absolutely Fabulous* and Wallace and Gromit's *The Wrong Trousers*.

Alan was appointed Controller of BBC One in 1993, significantly improving its content and share. He became Director of Programmes in 1997, then Director of Television in 1998. In June 2004 he became the BBC's Creative Director.

His outside responsibilities include Chair of the Trustees of the children's charity, Kids Company.

By Angela de la Cruz

I was very interested to be part of the panel that judges the John Moores Painting Prize because as a painter myself, I was curious to see the state of painting in Britain today.

I was firstly surprised at how many animals and pets are the subjects of the paintings made in this country. My guess is that the ones of exotic animals must be made by artists who are born abroad, by people who travel a lot, or even those visiting the zoo. It is also important in this matter to consider the power of television and media; these create a parallel reality through which you can watch the world from your own home.

I was intrigued to see images that seemed to represent war zones or elements of war. But also, I wanted to see the realistic paintings because they represent how society is at this very moment. I am very concerned about climate change and war. It is very important for me to think about how society is developing in this, the era

of migration, and about how many people are moving around the world. The John Moores Painting Prize represents that movement through the artists who enter the competition; I wanted to see their reactions and observe how they reflect all these changes in their work. I was also drawn to the concept behind the paintings I saw: some of them seemed very cathartic. At the same time I felt that the painters who enter the John Moores represent a very various and multicultural Britain.

There was also a temptation to try to recognise painters I know, but as there were so many, and this is an anonymous, democratic prize, I had to resist.

I took the task of selecting very seriously out of respect for people who make art all the time. It is very difficult to be an artist today – there is not much money involved and success is often a question of luck – yet artists have to work very hard, every day.

I would like to praise the Moores family and the people who organise this competition, year after year. It is a gruelling task.

The experience of being a juror was very rewarding and I thought a lot about the paintings I saw. It was also interesting to hear the opinions of the other panel members and to see what they chose.

The John Moores Painting Prize is one of the major prizes for painters in this country, and entering it is surely a *must* for them. This Prize can make an artist's career. While it is very important if you win it, being part of the exhibition itself is also very prestigious. The panel's duty was to select the artists to take part in the exhibition, and this was indeed a very difficult task, but at the end of it, we were very satisfied with the results. I would like to congratulate all of the artists who have been included in the exhibition and particularly the winners: you all truly deserve to be included.

Condemned to the Adjective[1] (Notes from a Selector)

By George Shaw

June 2011

I've been asked to be one of the selectors for the John Moores 2012. Will this be interesting? Who are the other selectors? Will it take up days and days and days? Why would I do such a thing? Art competitions and prizes are strange. I've avoided giving it too much thought for some reason. From the earliest age the drawings and paintings I've made have been judged and marked out of ten so I suppose I've come to expect it. But it's not how it should be, is it? Is it about approval, acceptance, belonging? Thinking about it like this makes me a little awkward and ashamed. My contribution to this culture of approval and disapproval goes against how I like to think of myself. But perhaps saying no to being a selector is a coward's decision. I should say yes and bring along my doubts and hypocrisy to the party.

I remember being in a shared studio space in the early nineties full of painters gearing themselves up for painting 'The John Moores Painting' and submitting it. Being in the exhibition was a bit like being blooded.

December 2011

As I'm thinking about judging, I get judged myself and end up in the Turner Prize runner-up bin. It also reminds me why I said yes to this: to be on the other side of the fence and see whether my worst fears and best thoughts can be true?

February 2012

A huge parcel arrived. It's a book of all the entries for the John Moores. Each painting is reproduced with its title, size and medium. The artist's name is *not disclosed to the selectors.* Did I know this? I'm not sure I knew this when I entered in 1999. I must have known this but not given it much credence. It certainly seems important now, when I'm looking through this book. I keep wanting to know who made the work. Sometimes I recognise the painting, or I think I do. I want it not to matter but I'm being nagged by how I've come to look at art. I'm drowning in a public baths of anonymity. It's not the best way to look at paintings, or anything really. I'm not doing anybody any favours, which I suppose is the point. I'm beginning to feel ruthless

and guilty. There are 3,000 paintings. If I spend a minute on each painting that's 50 hours; so roughly a working week. That seems fair enough. Together with the book there is a CD so I can look at each painting on the screen. The idea at this stage of the selection process is for each selector to take out those paintings they aren't interested in. This should leave us with a short list to look through when we meet later on. I sit down in my judging chair with my judging head on. There's quite a lot of crap. I mean *real* crap. For once I feel liberated by the anonymity and begin to enjoy myself. Halfway through the first day I begin to know what is meant by the death of painting. How can it be that I'm moved so little by so much? It's like watching TV and when something is good, or at least interesting, it really stands out. I wonder if the other selectors feel like this. Am I being a bastard? Am I being horribly dismissive? I begin to feel sorry for the people who've made the work that I've just put a cross through and I have to remind myself that I'm judging the painting and not the painter. I'm not putting a cross through their life – it's just a painting competition. After a couple of days I realise that I have no agenda or criteria other than saying what I like. It seems a little puerile but my nervous

system is working way ahead of any intellect. The isolated image has to trigger something that in turn leads to other fires prompting more looking and more curiosity. What I'm being left with is that which survives scrutiny, which is always ahead and *un*consumable.

On the radio the other night I heard an old *Beyond our Ken* sketch which began with the line 'Contemporary Art; is it as bad as it's painted?'

March 2012

I'm sat in a room in West London, kitted out for AV presentation. There's tea and coffee and it all looks ready for serious business. We are due to look at and discuss the works we have all chosen. To be honest I feel a bit nervous. I've never been drawn to open debating and I've spent most of my adult life making decisions on my own. As we start looking at the paintings one of the selectors is super-clear about what they want – "no, no, no, no, no, no, no, no, yes, no, no, no, no" – and I begin to feel that I've been too lenient. Another selector has identified certain trends or movements and is keen to discuss these within the

context of the wider art history and specifically contemporary art practice, and I begin to feel a complete fraud who *doesn't know much about art but knows what he likes*. I have more in common with one of my colleagues who is curious and a little undecided but confident with it. A fifth selector can't make it and has sent a list of their choices. I begin to agree with everybody and my own opinions are getting ready to get the first train home. I can't help feeling that it's all a bit *X Factor* or *Britain's Got Talent* but not being a fan of these programmes I've not seen them so I don't really know if it's like that at all. Perhaps it's more *Opportunity Knocks*. A 'Clapometer' would certainly be useful. Like singing, everyone thinks they can have a go at painting. I suppose it has something to do with the immediacy and simplicity. It doesn't appear that there's much to it and when it's done well comes over as a natural act like breathing or shitting. It's also difficult to identify why I like a particular painting or song. Sometimes it has nothing to do with the artist's ability. In fact sometimes ability gets in the way. But in the way of what? A vision? A thought? An identity? What is this most basic act for? Perhaps I'm looking at it the wrong way about. That the medium isn't a medium - as in a

séance - to allow the voices from another world to have a presence in this world. It is a thing in itself, a fact of life that is somehow affirmed by the act of doing it.

But as the day unfolds it gives way to thoughtful and generous conversation and decisions and proves to be a kick up the arse to my own negative paranoia.

The evaluation will be made outside of any law, outplaying not only the law of culture but equally that of anticulture, developing beyond the subject all the value hidden behind 'I like' or 'I don't like'. Singers especially will be ranged in what may be called, since it is a matter of my choosing without there being any reciprocal choice of me, two prostitutional categories. Thus I shall freely extoll such and such a performer, little-known, minor, forgotten, dead perhaps, and turn away from such another, an acknowledged star...[2]

May 2012

Today we get to see actual paintings. We are all sat on comfy chairs and technicians bring the works in from a room on the left for us to look at and talk about,

and they get carried off to the right as either a 'Yes', a 'No' or a 'Don't Know'. There are lots of 'Don't Knows'. I keep looking at how the paintings are made; the canvas or board, the paint surface, how the paint has been applied, but unlike a SOCO it tells me nothing. I'm not that interested in hardware. I feel unsettled. I think I'd have liked to have seen all the paintings. Everything I've got rid of lingers in the corners and haunts the room. We add to this haunting with each decision. By rights I should be focussed on what we've chosen, not what we've rejected, but it's in my nature to think about death. My imagination keeps drifting to the graveyard we've made and what kind of an exhibition that would make. Fortunately my fellow selectors are more focussed and by the end of the long day an exhibition has taken shape. I'm still intrigued by how we have arrived at this selection. It does rely on some kind of agreement, some kind of consensus but I don't recall there being one evident. Time was perhaps the only real governor. Without the clock on the wall we could very well end up with everything or nothing. As selectors we are all roughly from the same corner so what does operate as a framework is a certain kind of education and an expectation of what

art has the potential to offer; a note that chimes with the reality of experience, be that aesthetic, cultural or psychological. A banker, a footballer and a plumber would obviously have selected an entirely different exhibition.

I'm as much in the dark at the end as I was in the beginning, as much in the dark about *why* as I was in the dark about *whom*. For me these mysteries are far more exciting than answers. Being in the know is overrated. The philosophical whining doesn't get anything done. When asked about the philosophy of humour, Ken Dodd referred to Freud (not Lucian) who *said that the essence of the comic was the conservation of psychic energy. But then Freud never played Second House, Friday night at the Glasgow Empire.*

[1] *The Grain of the Voice*, p.180, Roland Barthes in *Image, Music, Text*, translated by Stephen Heath, Fontana Press, 1977
[2] *The Grain of the Voice*, p.188, Roland Barthes in *Image, Music, Text*, translated by Stephen Heath, Fontana Press, 1977

First prizewinner

Sarah Pickstone

Sarah Pickstone

Stevie Smith and the Willow

2011
Oil, enamel and acrylic on aluminium panel
198.3 x 229 cm

How do we define image? Is image a visual thought? Do all images have their source in other images, or associations with other images?

Stevie Smith and the Willow is a painting from a series of works which nod towards creative communality. It has at its heart the drawing that accompanies Stevie Smith's 1957 poem, 'Not Waving But Drowning'. Smith was definitely an original, whose poems (and pictures) make a confluence of the comic and the metaphysical. In the painting, the girl (artist, poet, reader, child) bathes in the water under an old weeping willow: part tree, part self, part story, part rebirth.

I've been working for the past three years on the ways in which figures, places and ideas meet and open each other, specifically referencing writers who happened, in history, to pass through London's Regent's Park. The park has long been a source for my work, a place where the public and the private, the external and the psychological worlds, come together. It's also a place of constant renewal. The painting is about this renewal, natural and aesthetic, across form, time and image.

Biography

Born in Manchester in 1965, Sarah Pickstone attended the University of Newcastle upon Tyne 1983-7, Royal Academy Schools London 1988-91. Awarded Rome Scholarship 1991-2. Group shows include *Morpho Eugenia* Galleria d'Arte Moderna e Contemporanea Republicca di San Marino Italy 2005, *Gibbous Moon* Cubitt Studios London 2007, *Irony and Gesture* Kukje Gallery Seoul Korea 2008, *Double Interview* I-MYU Projects/Seoul Art Space Korea 2010, *Layers: John Moores Contemporary Painting Prize Show* Seongnam Arts Centre South Korea 2010. Was a prizewinner in *John Moores 23* 2004. Based at Cubitt London, her current work includes an Artist Book project with writer Ali Smith.

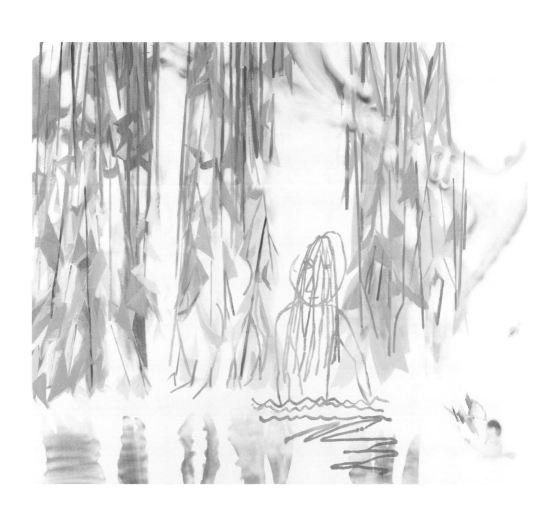

Sarah Pickstone

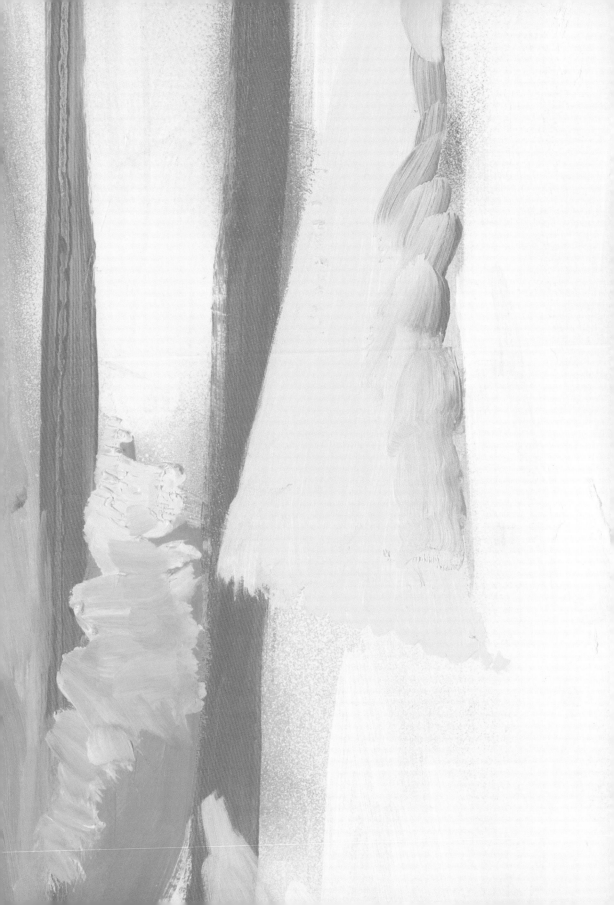

Prizewinners

Biggs & Collings

Ian Law

Stephen Nicholas

Narbi Price

Biggs & Collings
The Greater Light

2012
Oil on canvas
203.5 x 203 cm

Biggs conceives the colour, Collings applies it. Our form is a series of triangles in a grid. We use it not as an idea in itself, or as a quote from life (wallpaper or golfing sweaters, for example), but as an inert container for colour. Meaning is everywhere, it looms up in spite of ourselves, but we aim to examine what the world looks like if you remove familiar forms with their confusing narrative resonances, and substitute a neutral structure. One that supports a complex, changeable colour harmony - a landscape painting without the landscape.

Painting is in crisis – what is the point of an antiquated form in a world where representation is ubiquitous? Our answer comes from looking at its origin, both in the history of art and as the by-product of art's original intentions: beauty. As with all our recent work, the title comes from *Genesis*, whose origin myths are integral to Christian, Jewish and Islamic history. (In this case, *Genesis 1:16: 'God made two great lights – the greater light to govern the day, and the lesser light to govern the night...'*) These tales inform early Western depiction, which is the starting-point for our visual enquiry.

Biography

Emma Biggs, born 1956, attended Leeds University (Fine Art) 1976-80 and is a professional mosaic artist. Matthew Collings, born 1955, attended Byam Shaw School of Art 1974-8 and Goldsmiths London 1990-2. He has written and presented TV programmes about art and was a juror for *John Moores 22* 2002. Since 1998 Biggs & Collings have worked collaboratively.

Exhibitions (London unless stated) include *Round Table* MOT International 2005, *HA HA WHAT DOES THIS REPRESENT?* Standpoint Gallery 2012. 'Solos' include *Clickclack* 2006 and *English Primitive* 2008 FAS Contemporary Art, *Five Sisters* York St Mary's York 2009, *Mudlark* Charlie Dutton Gallery 2010, *The Whole Earth* Vigo 2012.

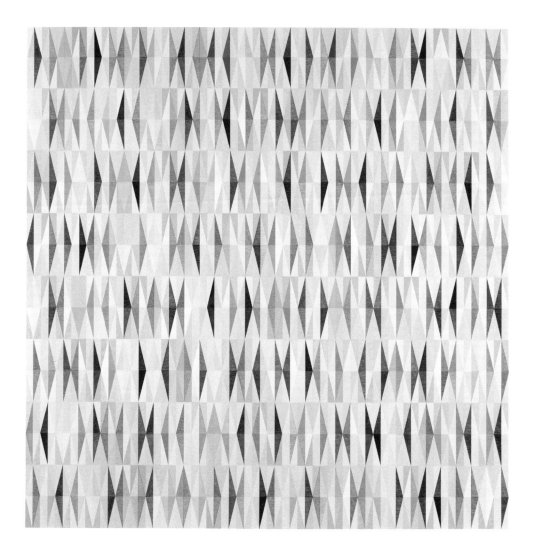

Biggs & Collings

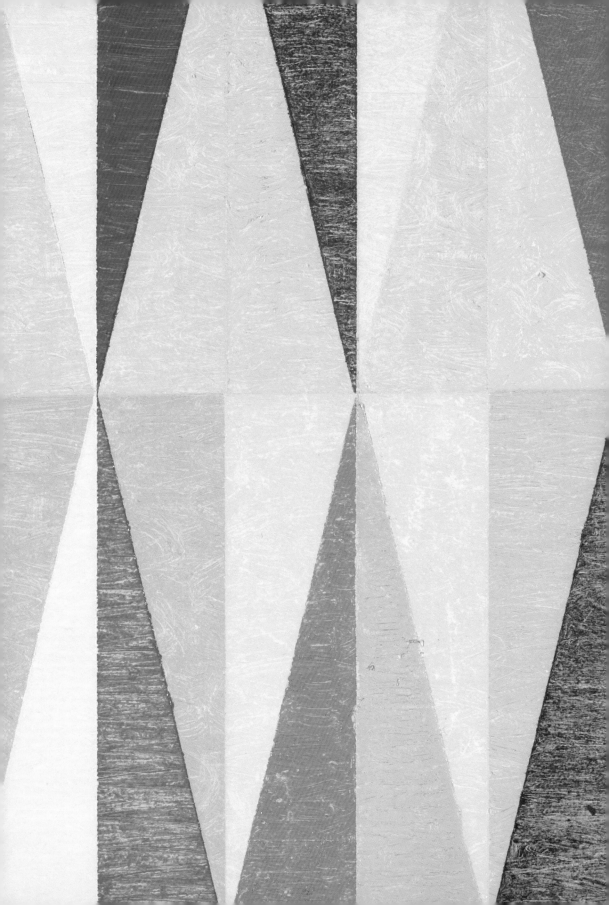

Ian Law

M is many

2011
Oil on linen
232.7 x 276.2 cm

M is many operates as a structure. It retains the dimensions of a wall previously installed within the gallery it was removed from. The M serves to delineate the proportions of the canvas, stating itself as a singular character whilst standing amongst the plurality of multiple readings.

The focus here does not fall upon gesture or authorship, but sets to move the work outside of its surface, implicating the viewer, artist and structure within its present context. How might we view a monument without a plaque?

Biography

Born in 1984, Ian Law lives and works in London, where he studied at the Royal College of Art 2007-9. Group exhibitions include *Session_3_Image* Am Nuden Da London 2009, *Furnished Space* London 2009, *A very, very long cat* Wallspace New York 2010, *History of Art, the* The David Roberts Art Foundation London 2010, *Programme Three: The Studio as Non-Place* Perth Institute of Contemporary Art Australia 2011, *Young London* V22 Workspace London 2011. Solo exhibitions include *Add a description* Galeria Plan B Berlin 2011, *Is many* Supplement London 2011, *Co-* Laura Bartlett Gallery London 2011 and *make sure* RODEO Istanbul 2012.

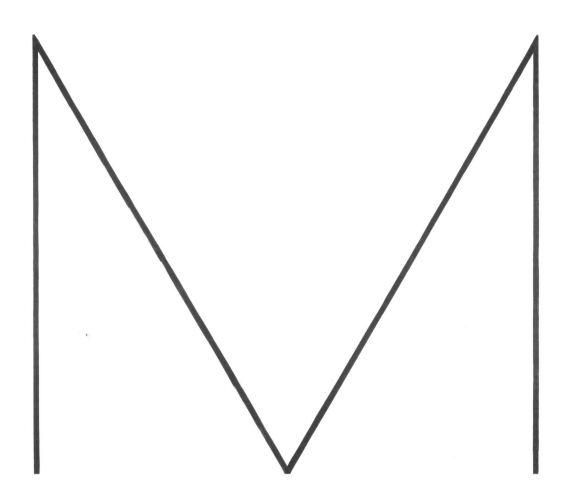

Ian Law

Stephen Nicholas

Gallery

2011
Oil on canvas
152 x 183 cm

This painting is one of a series which explores the theme of viewing/observation spaces. Others in the series include parachutists falling and floating inside a room, and monkeys jumping, as if being disturbed.

The painting explores a number of dualities: gallery and institution, abstraction (as quotation) and figuration, perception and a viewing purpose/function.

The image was based initially on a shooting range and evokes a gallery space and modernist viewing room akin to a laboratory.

The targets (figures) are ghosted out through light over-painting, rendering them fugitive. The black discs (holes, penetrations) are a quotation from Op Art and disrupt the picture surface - they throw off an optical image of white discs if viewed in specific light.

The physical surface of the paint and the handling is just as important to me as the image; for me they are inseparable.

Biography

Stephen Nicholas was born in 1958 in Shoreham by Sea, Hove, and studied at St Albans 1979-81 then Falmouth School of Art 1981-4. Group exhibitions include *The Happy Squirrel Club* (curated/produced by BANK) De Fabriek Eindhoven 1996, *Instantaneous* Beaconsfield London 1996, *Mommy Dearest* Gimpel Fils London 2000, *The (Ideal) Home Show* Gimpel Fils London 2001 and *A Thing About Painting* Platform London 2002. His solo shows include *Flicker Narcissus* Beaconsfield London 1994, *It's my party and I'll die if I want to* De Verschijning Tilburg 1996 and *Lapse* Platform London 2000.

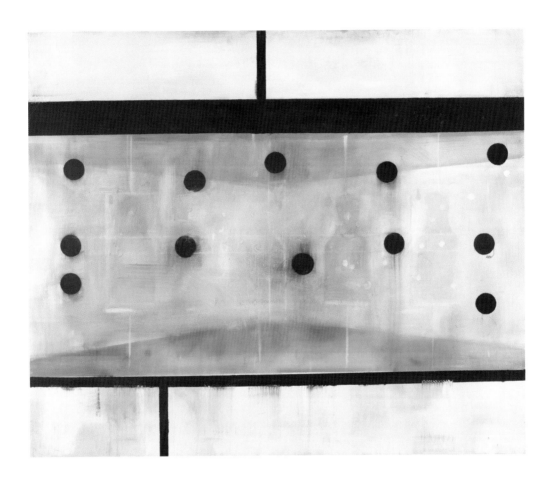

Stephen Nicholas

Narbi Price

Untitled Kerbstone Painting (MJK)

2012
Acrylic on canvas
91.5 x 122 cm

My socks were wet in my shoes when I saw Narbi's new paintings last Wednesday, and my black woolly hat was soggy. I'd just come in from outside. From the window of the room he works in, it was somehow soothing to see the scruffy backsides of the buildings you normally only see from the street, particularly the rear of the now-closed Odeon cinema. Rain was still falling on that arrangement of brick, ceramic tiles and weeds. I love stuff like that, and know Narbi does too.

I had some thoughts about his paintings, and then we talked, and then I had some other thoughts. Previously, I'd celebrated his choice of the neutral object, the one that neither attracts nor repels; and the act of rendering its mundane image with such precision and tenderness. This time, his choice of object had been driven by something else.

I'm still thinking about Narbi's pictures. And, I suppose, about that huge cinema screen hanging in the derelict dark, and all the films that were projected onto it – romantic films, comedies, kids' films, horror films – none of which have left the slightest trace.

Text by Nev Clay, April 22, 2012.

Biography

Born 1979 in Hartlepool, Narbi Price attended Northumbria University 1999-2002, Newcastle University 2008-10 (MFA). Group exhibitions include *PRINT* Mushroom Works Newcastle upon Tyne 2009, *9* ACADovetail Newcastle 2011, *Nothing, Like Something, Happens Anywhere - New Work by Narbi Price and Neil Cammock* Moving Gallery Newcastle 2011, *Hole Editions - Ink on Paper* Durham Art Gallery and DLI Museum 2011, 2-person show with Marc Bijl GalleriaSIX at *Arte Fiera* Bologna 2012 and *Omnia Mea Mecum Porto - Works On Paper* Kotti-Shop Berlin 2012. His site-specific solo show *Narbi Price* was at GalleriaSIX Milan 2011. Exhibited in *John Moores Painting Prize* 2010.

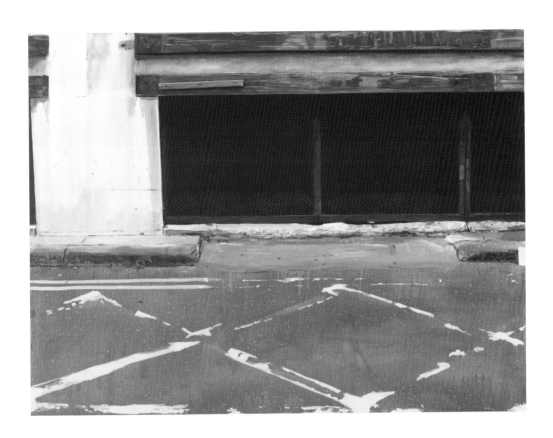

Narbi Price

Artists

Eve Ackroyd
Henny Acloque
Kelly Best
Katrina Blannin
James Bloomfield
Hannah Brown
Jane Bustin
Graham Chorlton
Wayne Clough
Julie Cockburn
Paul Collinson
Andrew Cranston
Theo Cuff
Cullinan Richards
Bernat Daviu

David Dipré
Nathan Eastwood
Liz Elton
Oscar Godfrey
Vincent Hawkins
Bé van der Heide
Rae Hicks
John Holland
Kevin Hutcheson
Jarik Jongman
Laura Keeble
Robin Kirsten
Brendan Lancaster
Laura Lancaster
Dominic Lewis

Peter Liversidge

Angela Lizoń

Elizabeth Magill

Danny Markey

Enzo Marra

Rui Matsunaga

Onya McCausland

Dougal McKenzie

Damien Meade

Sonia Morange

Pat O'Connor

Jay Oliver

Dan Perfect

Oliver Perkins

Virginia Phongsathorn

Tom Pitt

Kevin J Pocock

Sarah Poots

James Ryan

Andrew Seto

André Stitt

Trevor Sutton

Emma Talbot

Amikam Toren

Matt Welch

Ian Whittlesea

Thomas M Wright

Eve Ackroyd

Dead Man

2011
Oil on canvas
46 x 60 cm

Often drawing on historical events, my paintings use news and found photographs as their source imagery. A document of a moment of human horror, such as an earthquake or the aftermath of a bombing, is reinterpreted in my paintings into a non-specific scene of human emotion.

Apart from the figures in my paintings, the surroundings are often bare. By displacing these images from their context, their narratives become isolated. Notions of pain and pleasure, resistance or discomfort are reduced to gestures, while desire is explored in the bodies' relationship to space.

Through painting I am able to articulate my thoughts about social systems, in which daily events and history are presented through the prism of mass news media. My paintings strip away the political context, and what appear instead are patterns of instinctive human behaviour.

Biography

Born in Guildford in 1984, Eve Ackroyd studied painting at Chelsea College of Art 2002-6, undertaking a Socrates Erasmus Scholarship exchange at Weißensee Academy of Arts Berlin in 2005. Group exhibitions include (Strich auf!) Galerie Pankow Berlin 2005, Space ASC Studios London 2007, Between Shadows Concrete & Glass London 2008, Par-A-Dise (2 person show) Dazed Gallery London 2008, Underfoot 97-99 Clerkenwell Road London 2010, Werkhaus The Rag Factory London 2011, Told Cole London 2011 and recently The Yellow Wallpaper The Cob Gallery London 2012. A solo show with Cole Gallery was at Art HK11 Art Futures Hong Kong 2011.

Eve Ackroyd

Henny Acloque

277

2011
Mixed media on canvas
30.6 x 40.5 cm

Appropriating the work of deceased artists, I forensically unpick and reassemble the layers of each image I work from. I view my paintings as being evidence of evidence. I bind the paintings (mostly oval) with a glossy resin. This gives a sense of infinity, inferring that both the landscapes and our ideologies expand and contract outside the image.

The recent paintings are images taken from a collection of catalogues and postcards from my family. Dwellings or ruins feature repeatedly, representing lost ideologies. I have eliminated all the figurative elements from the originals and enforced my own codes to re-introduce characters to the frozen worlds. I have utilised the colour of cloth from the figures in the reproduction image and injected swoops and strokes that wittily and darkly undermine and disrupt the fantastical visions. This notion of 'owning' the painting is literally played out, with colours becoming fatter and more garish, suffocating and squeezing the image underneath.

In this series of works I hope subtly to prise open collections (and collectors) to reflect on how our changing world finds new meaning in their legacy, and how changes to society, culture and the economy have radically reshaped the meaning of objects and our relationships with them.

Biography

Born in London in 1979, Henny Acloque studied at UWE Bristol 1999-2002. Group shows include *Kings, Gods & Mortals* Hamish Morrison Gallerie Berlin 2009, *Jerwood Drawing Prize 2009* Jerwood Space London (touring), *Exeter Contemporary Open 2010* (winner) Phoenix Gallery, *Black Hole Hums B Flat* Ceri Hand Gallery Pop-Up Space London 2010, *Fade Away* Transition Gallery London 2010, *Polemically Small* Garboushian Gallery Los Angeles 2012, *Memory of a Hope* Ceri Hand Gallery Liverpool 2012, *The Threadneedle Prize* Mall Galleries London 2012. Solos include *A Dressing* 2009 and *Lugar De Culto* 2012 Ceri Hand Gallery Liverpool. Included in *John Moores 24* 2006.

Henny Acloque

Kelly Best

That place between 11 and 12

2011
Oil on canvas
120.5 x 160.5 cm

My recent paintings are of landscapes that ask for reflection, and challenge our concept of time and place, questioning what we know as real and exploring what we think is invented.

I work by extracting ideas from my own photographs and found images, and incorporate them into the paintings in a collaged approach until they respond with the painting, creating a new identity. These forms dominate the space that surrounds them, yet the space around them also defines them.

I am interested in creating tangible boundaries in the paintings as well as allowing them to appear naturally during the painting process. The tactile nature of the canvas surface and the texture of the paint are key to my paintings. Combining impasto and thinner layers produces clues to the history of the painting whilst adding ambiguity to the landscape. Playing with perspectives forces the viewer to question their own position in relation to the space.

Biography

Kelly Best was born in Kent in 1984. She studied at Kingston University 2004-7 and is currently based in Cardiff. Her group shows include *Contemporary Painters* Bute Space Gallery Cardiff 2009 and various *Open Studios* at Studio B Cardiff 2010-11. In 2011 she was an Artist in Residence at The Stade Hall, Hastings, exhibiting in *SALT* at the Coastal Currents Festival 2011. She was recently short-listed for *The Door Prize for Painting 2012* Centrespace Gallery Bristol.

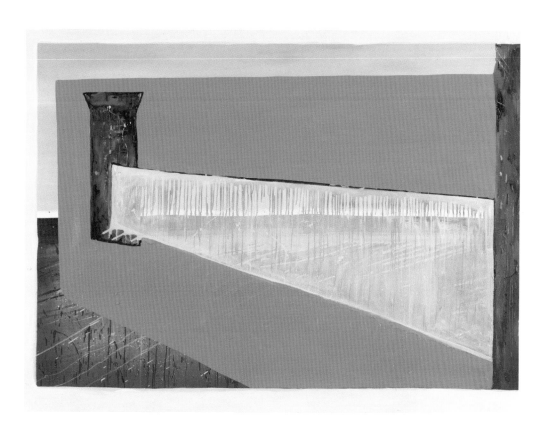

Kelly Best

Katrina Blannin

Pink

2012
Acrylic on linen
56 x 54 cm

Pink follows an evolving methodology. Squared grids provide the starting point for a 'diagram' or 'mosaic' of tessellated triangular forms and hexads. It is a reflexive, systematic approach, which searches for a lucid, visual sense, something that artists such as Mary Martin would describe as 'internal logic'. In making a diptych I have the idea of mirroring or ghost images in mind. The starting points are objective explorations of the simple mathematics of symmetry, sequence and the possible disruptions of asymmetry. But this is only part of the journey. The aim is to achieve, through a paring down of visual ideas, something which investigates perception, intelligibility or clarity. During the process instinct and experience play a role in relation to weight of tone, colour nuance, consonance and dissonance. Painted panels are applied in glazes, either multi-layered or in thinner washes. In others, metallic or multi-coloured under-painting is revealed which, with the texture and weave of the linen, creates a kind of two-tone effect, becoming integral to the tonal composition. Whatever the intention, the finished work is never completely as envisaged. It is the power of surprise that is important, its Gestalt, or ability to be more than the sum of its parts.

Biography

Katrina Blannin was born in London in 1963, attending Portsmouth Polytechnic 1984-7 and the Royal College of Art 1995-7 (Drawing Prize 1996). Group shows, all London, include *Celeste Art Prize* Old Truman Brewery 2006, *Painting Show* 1.1 Gallery 2006, *Crash Open Salon 2010 and 2011* Charlie Dutton Gallery, *Zig Zag* Charlie Dutton Gallery 2011, *Friendship of the Peoples* Simon Oldfield 2011, *HA HA WHAT DOES THIS REPRESENT?* Standpoint Gallery 2012, *Double Vision* Lion and Lamb Gallery London 2012. Solo shows, all London, include *New Paintings* Beedell Coram 2005, *Local Colour* Eleven Spitalfields 2009, *Hexad* Price and Myers 2010/11.

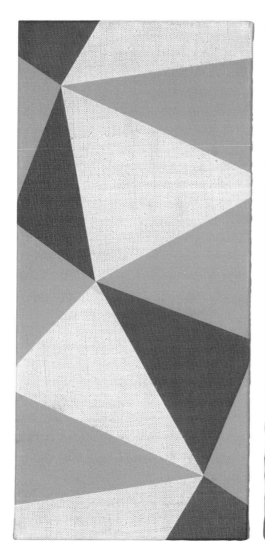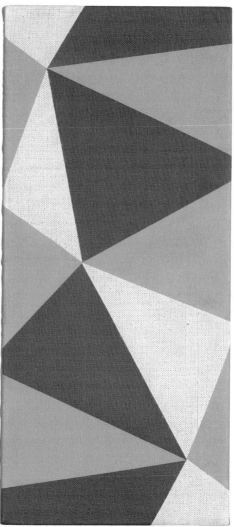

Katrina Blannin

James Bloomfield

Collateral Damage – The Killing Jar – 14.1.2012

2012
Household paint on reclaimed plasterboard
88.4 x 117.5 cm

Images from the conflict in Iraq and the war in Afghanistan have become part of our everyday lives. This painting is part of a series assessing how de-sensitised we are becoming to daily reports of death and murder. The painting represents a still from Julian Assange's WikiLeaks footage showing the shooting of 15 Iraqi people.

Biography

Born in Rossendale in 1977, James Bloomfield studied art at Manchester Metropolitan University 1995-6, and has studied painting conservation, broadcast media and sound recording. Group shows include *Artist Run* Cow Lane Studios Salford 2003, *Music* 5a The Gallery St Helens 2004, *Salford 7* Salford Museum and Art Gallery 2004. Solos include *Salford 7* Farmilo Fiumano London 2005, *M12-11* Stockport Art Gallery 2008, *It's our Salford* Salford Royal Hospital 2008 and *The Killing Jar* AWOL Studios Manchester 2010. He has worked on several public art projects, is Artist in Residence at LIME Art Manchester 2011-13 and Studio Manager at Pool Arts Manchester.

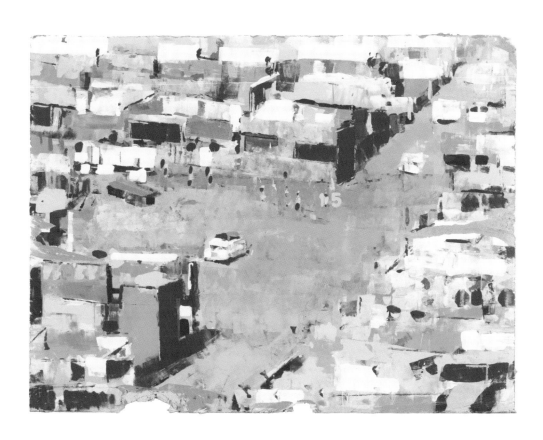

James Bloomfield

Hannah Brown

Time Hangs Heavy 3

2011
Oil on oak and plywood
23 x 26.8 cm

My work centres on the English landscape and the way it is represented and reproduced. Working within and against the omnipresent legacy of the English landscape tradition, I search for quiet, often overlooked places with a peculiar type of beauty.

I am interested in the paradoxical desire to seek the picturesque within the natural environment and then promptly alter it by creating one's own version; to hold a lasting possession of a place by imposing one's description, thoughts or ideals.

The images I make are carefully mediated versions of our landscape. They are emptied of people and obvious signs of life. The weather, time of day and sometimes even the content are altered at will. What starts as a kind of ode to our landscape results in work with a prevailing sense of menace due to the untruths in the execution and the muted palette I favour, reflecting the flat, grey, English light that is so familiar.

Biography

Hannah Brown was born in Salisbury in 1977. She studied sculpture at Central Saint Martins 1996-9 and the Royal College of Art 2004-6. Group exhibitions include *Day-to-Day Data* Angel Row Gallery Nottingham (touring) 2005/06, *Downstairs Review* Gimpel Fils London 2007, *Creekside Open 2009* (selector Mark Wallinger) APT Gallery London, *Modern British Sculpture* Gimpel Fils 2011, *Encounter* Gallery Primo Alonso London 2011, *Creekside Open 2011* (selector Phyllida Barlow) APT Gallery, *The Threadneedle Prize* Mall Galleries London 2011 and *The Launch* A-side/B-side London 2012. Solo exhibitions are *Hannah Brown* Gimpel Fils 2006 and *Time Hangs Heavy* The China Shop Gallery Oxford 2012.

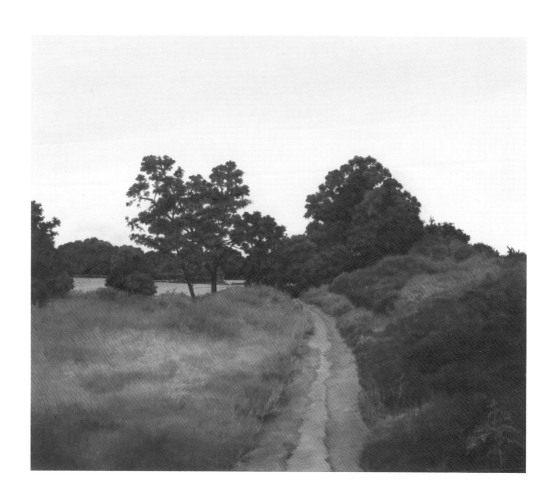

Hannah Brown

Jane Bustin

— sacrificed
— to veil

— sacrifiés
— pour voiler

2011
Oil on muslin, oak and gesso on MDF
127 x 91.5 cm

My recent work explores the metaphysical potential for painting to 'make visual' philosophical concepts found primarily in literature as well as music, science and theology, and are presented within the formal constraints of abstraction. Over several years, they have been an exploration into making visual the unsayable. The paintings and the space around them resemble the thoughts and pauses upon a blank page. They are initiated following intense periods of research resulting from collaborative projects with writers including Andrew Renton, Sally O'Reilly, Hélène Cixous, Tracy Chevalier and John Hull. The collaborative projects have included *Atemwende*, *Darkness Visible* and *Unseen*.

The recent series of paintings has been made in response to Stéphane Mallarmé's unfinished poems 'Pour un Tombeau d'Anatole'. These fragments of text were Mallarmé's attempts to come to terms with the death of his eight-year-old son, Anatole. Each work consists of three or four painted objects arranged on the wall and floor.

Biography

Born in 1964 in Hertfordshire, Jane Bustin studied at Portsmouth University 1983-6. Group shows include *Face Off* Kettle's Yard Cambridge 2002, *ID* Ferens Art Gallery Hull 2005, *Darkness Visible* Southampton City Art Gallery 2007, *Summer Exhibition* Royal Academy of Arts London 2011, 2012, *Back and Forth* B55 Gallery Budapest 2012. Solo Shows include *Atemwende* Eagle Gallery London 2000, *Paintings* Artprojx Space London 2008, *Unseen* British Library London 2009 and *Anatole Notes* Testbed 1 London 2012. Her work is in several collections including the Victoria & Albert Museum London, Yale Center for British Art New Haven and Ferens Art Gallery Hull.

Jane Bustin

Graham Chorlton

Edge of Town

2011
Acrylic and oil on canvas
51 x 61.2 cm

Edge of Town shows an in-between place, where the urban sprawl gives way to something else. We might be anywhere in Europe, where new apartment blocks were built in the '50s and '60s to extend growing cities. A narrative may be suggested, but this is held off in this moment of stillness, when you become aware of where you are.

The painting process teases imagery out of washes of paint. The paint itself is an image and forms a relationship with that which is represented. I am concerned with how and what we represent, and with embedded time, of the past within the present, and the capacity of place to embody experience and memory.

Biography

Graham Chorlton was born in Leicester in 1953. He studied at Leeds University 1972-6 and is Senior Lecturer in Fine Art, Coventry University. Group exhibitions include *East* Norwich Gallery 1993, *The Obsessive Garden* Ashford Gallery RHA Dublin 2006, *Dialogue* Halle des Chartrons Bordeaux 2010, *The Witching Hour* Birmingham Museum and Art Gallery (touring) 2010/11, *Some Domestic Incidents* (curator Matt Price) at Prague Biennale 2011 and *There Is A Place* New Art Gallery Walsall 2012. Solo shows are *Hotel Minerva* Master Piper Gallery London 2009 and *Parks, Hotels and Palaces* Cross Gallery Dublin 2012. Exhibited in *John Moores 17* 1991.

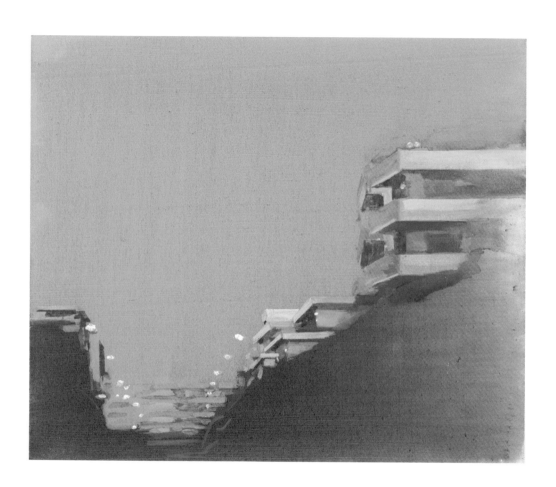

Graham Chorlton

Wayne Clough

Down the Acapulco

2012
Tempera on paper, white wooden box frame
29.2 x 33 cm

Whilst adopting the position of painter/archivist, I aim to investigate the way in which personal and societal experience is represented through press photography. Images that focus on trauma and social upheaval appear to play a significant role in shaping collective memory along with galvanising perceptions of cultural identity.

Down the Acapulco is one of a series of transcriptions that depict traumatic events that have punctuated various moments within my lifetime. These events seem to serve as a kind of memory map of lived experience.

This painting was given a special commendation by the jury.

Biography

Born in Bradford in 1975, Wayne Clough attended Bradford College 1998-2001 and Wimbledon School of Art London 2004-5. Exhibitions include *Working for Peanuts* Space 44 Studios London 2005, *MA Show* Wimbledon School of Art 2005, *Painting to Music* The Music Room London 2005, *The Triumph of Panting* The Music Room 2006, *Whatever Happened to the Leipzig Lads?* (curator, with James McMeakin) Waterloo Gallery London 2006, *Histories* (curator, with James McMeakin) Foss Fine Art London 2008, *Rhizomatic* Departure Gallery Southall 2010, *Royal Watercolour Society Open* Bankside Gallery London 2011 and *Creekside Open* (selectors Phyllida Barlow, Dexter Dalwood) APT Gallery London 2011.

Wayne Clough

Julie Cockburn

The Field

2012
Glazed ceramic and oil on found painting, bespoke frame
38.8 x 49 cm

The Field is one in a series of works made using found paintings as my starting point. In each case I responded to the image/object with some act of defacement. This painting exists on three planes: first, a physical background of a found canvas; second, a layer of black oil paint, semi-obscuring the original image; and third, floating glazed ceramic shapes, their acerbic colours contrasting with the duller hues still visible in the original painting. These glossy sentinels contain the painting and insist upon a dynamic vacillation between object and surface.

The experience of looking at a painting is somewhat similar to engaging in a dialogue. A crucial factor in the process of making *The Field* is that it was never, as far as I was concerned, a blank canvas. Rather, I entered into a pre-existing, albeit moribund, conversation, and experimented with a personal visual language. This hint at the nature of both intrapersonal and interpersonal communication engenders in me, and hopefully the viewer, an awareness of the human longing to be in empathic relationship.

Biography

Born 1966 in London, Julie Cockburn studied sculpture there at Central Saint Martins 1993-6. Exhibitions (London) include *Jerwood Drawing Prize 2007, 2010* Jerwood Space (touring), *Exam* Transition Gallery 2011, *Photography as Object* Sumarria Lunn 2011, *The New Alchemists: Contemporary Photographers Transcending the Print* Photo50 London Art Fair 2012, *The World in London* (Photographers' Gallery commission coinciding with 2012 Olympics). Solos include *Filling The Cracks With Ceiling Wax* Flowers East 2010, *The Foul Rag and Bone Shop of the Heart* Matt Roberts Arts 2011, *Portraits and Landscapes* Flowers Cork Street 2012. Work is in collections including Yale Center for British Art New Haven.

Julie Cockburn

Paul Collinson

Temple of Ancient Virtue

2010
Oil on canvas
120 x 180 cm

The inherent *picturesqueness* (roughness and irregularity) of the abandoned, derelict and the unplanned space is a virtuous subject matter for the artist, now politically as well as aesthetically. So rather than go hunting for these already 'turned over' sites I make my own: low-tech follies of my own imagination and experience, mixed with references to historic and contemporary English landscape ideologies. They are designed and constructed to achieve a certain verisimilitude when viewed through the camera lens. The photographic print becomes the subject matter, not to ennoble or question the role of the photograph, but as a point of origin for the day-to-day exigencies and the tussle of painting the 'point of view'.

Biography

Paul Collinson was born in Hull in 1959 and studied Fine Art at Humberside Polytechnic 1989-91. Group shows include *The Way the Land Lies* Stamford Arts Centre Lincolnshire 2004, *The Miniature Worlds Show* Jerwood Space London 2006, *The Really REAL* Python Gallery Middlesbrough 2009, *Situation Critical* Wirksworth Festival Derbyshire 2011 and recently, *A Modern Romance* 20-21 Visual Arts Centre Scunthorpe 2012. His solo exhibitions are *Sights Unseen* Christchurch Park Ipswich 2004, *REALLY...* RED Gallery Hull and 20-21 Visual Arts Centre Scunthorpe 2008, and *England's Favourite Landscape* Artlink Gallery Hull and Myles Meehan Gallery (Darlington Arts Centre) 2011.

Paul Collinson

Andrew Cranston

Thinking Inside the Box

2012
Oil on canvas
137.2 x 212.5 cm

Painting is illusory, true lies, and my work affirms a belief in painting as a real kind of fiction. This premise offers the notion that a painter could be like a writer and adopt personas, explore feelings, thoughts, scenarios and characters rhetorically.
This painting is an elaboration on something seen and experienced.

Life drawing was thought to be an acceptable casualty in the ideological art wars following the Coldstream Report. However, Scottish art schools never really had a 1960s and went on pretty much as before, change happening more slowly.[*]

Architectural space itself may be the main character here, and the canvas acts as an analogous spatial box, which has walls, floors, sides, etc. There is an absurd element in making art in a room somewhere, living in a box. The title refers to the freedom found in limitations. Walls are not all bad, some are good and necessary to keep stimuli out; to frame and make sense of something, even the corner of a room.

[*]In the painting office at Gray's School of Art, an old staff diary entry from May 23, 1968 (at the height of the Paris student riots) reads *'Still Life Composition'*.

Biography

Andrew Cranston was born in Hawick in the Scottish Borders in 1969. He studied at Manchester Polytechnic 1989-90, Gray's School of Art Aberdeen 1990-3 and the Royal College of Art London 1994-6. He lives and works in Glasgow and Aberdeen. Included in *East International* Norwich Gallery 2007, 2009. He has had solo shows Mappin Art Gallery Sheffield 2002, *What a Man does in the privacy of his own attic is his affair* International Project Space Birmingham 2009, Hamish Morrison Galerie Berlin 2010. In 2006 he received the Rootstein Hopkins Sabbatical Award for lecturers and in 2008 the Scottish Arts Council Artists Award.

Andrew Cranston

Theo Cuff

Untitled

2011
Oil on canvas
47 x 37.5 cm

I paint from a cache of found and personal photographic material, from which a palette can be developed and applied in a process of reiteration or remedy. A ground serves as a constant where images are played out and often left in a state of uncertainty, complicated over time by marks and drips, and succeeding or failing according to cognition.

A precarious engagement between mimetic representation and abstraction then takes place - a need to extinguish or transform the initial image until equilibrium occurs. This then suggests a deferred residual quality to me, which is detached, yet knowing of its original content, opening up new meanings but holding a skewed familiarity.

Biography

Theo Cuff was born in Frimley, Surrey in 1984. He studied at the University of the West of England Bristol 2003-9. Gained MAstars award AXIS website 2009. His exhibitions include *Paint.Paint* Room 212 Bristol 2008, *Et in Arcadia Ego* The Crypt St Paul's Church Bristol 2009, *The Show 2009: UWE Fine Art Graduates Exhibition* Spike Island Bristol 2009, *Fade Away* Transition Gallery London 2010, Gallery North Newcastle 2011, *Exeter Contemporary Open 2011* Phoenix Gallery, *Six by Four* Motorcade/Flashparade Bristol 2012, *Last Day* Cartel Gallery London 2012. He was included in *John Moores Painting Prize 2010*.

Theo Cuff

Cullinan Richards

Collapse into Abstract (Black)

2010
Gloss paint on plywood, plywood frame
162.5 x 136.5 cm

Charlotte Cullinan and Jeanine Richards have worked together since 1997 as an artist duo, working primarily within the area of painting, painting's relationship to the structure of the exhibition, and painting as performance.

We are interested in the use of the exhibition as material context within which discreet objects are choreographed and re-arranged to give a sense of instability or slippage of material and meaning. The diving horse pictured in *Collapse into Abstract (Black)* originates from a spectacle, performed in 1921 on the pier of Atlantic City, New Jersey, USA. The diving horse connects with our interest in the performance, the painting being both a depiction and a provisional 'stand in' for the performer. The title positions the painting as a collapse of the representational towards action and gesture, a downward motion into matter - a *'plunging passage into blatant materiality and abstracted form.'* *

*Tom Morton, *'British Art Show 7 - In the Days of the Comet'* 2010/11, catalogue entry p58.

Biography

Charlotte Cullinan studied at the Royal College of Art, Jeanine Richards at Chelsea College of Art. Cullinan Richards' group exhibitions include *The Edge of the Real* 2004, *East End Academy 2009: The Painting Edition* both Whitechapel Gallery London, *Hey, We're Closed!* Hayward Gallery London 2010 and *British Art Show 7* (touring UK) 2010/11. Solos include *Pinxit* After the Butcher Berlin 2006, *Girl Rider* Mead Gallery Warwick 2008, *Strippers* Charles H Scott Gallery Vancouver 2008, *Maradona two – for four* The Lab Dublin 2010, *First Unaffected Unaffected Formal Effects Last* Cooper Gallery DJCAD Dundee 2010 and *Collapse Version V* Dispari&Dispari Project Reggio Emilia Italy 2011.

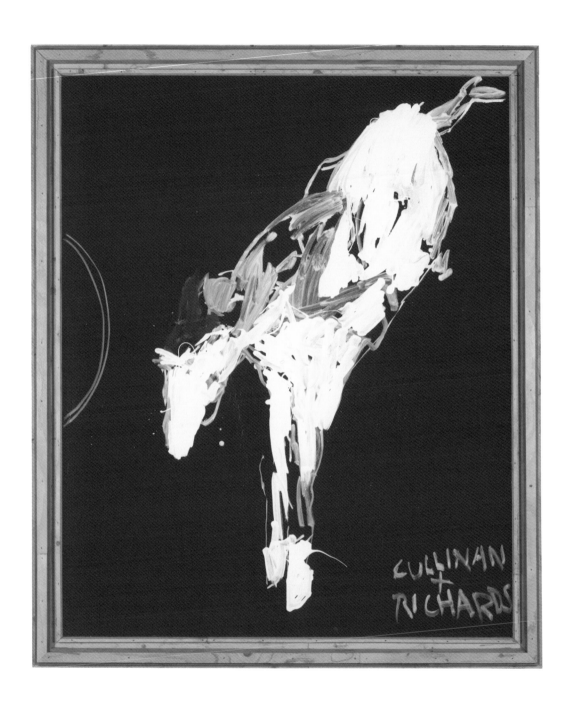

Cullinan Richards

Bernat Daviu

Overall Paintings

2011
Acrylic on canvas, wooden hangers
161 x 76 cm

In my paintings I reduce the image to a minimal expression of abstract forms. These become the motif of a system, generating imagery by means of alignments, distortions, displacements or superimpositions. Some paintings are later transformed into garments. These pieces resemble working smocks (modes of uniform) and they position paintings - and the act of painting - as potent objects in real space.

In this particular work, monochrome paintings are presented in the form of boiler suits. Both the Monochrome and the boiler suit are emblems of the Modernist utopian project in Russia after the Bolshevik Revolution (1917), in which art was to become a functional and practical tool for the construction of a new democratic society. The *Overall Paintings* represent historical relics of a previous era, as well as pictorial symbols open to performative interpretations.

Biography

Bernat Daviu was born in Girona, Spain in 1985. He lives and works in London, having studied there at Central Saint Martins 2004-8. Exhibitions include *Underground Temple For Paintings* (with Harry Blackett) Next Art Fair Chicago 2009, *Democratic Painting* IV Jafre Biennial Spain 2009, *'The decade 2010-2020.' The museum as hostage to fortune* The Pigeon Wing London 2010, *(Drive-Thru) Old Bridge* (with Harry Blackett, Sam Whittaker) Deptford X London 2010, *Stuff on the wall, on the floor, floating in the air...* Guest Projects London 2011. Solo show *The Real Van Gogh Part 2* Studio One Gallery London 2010.

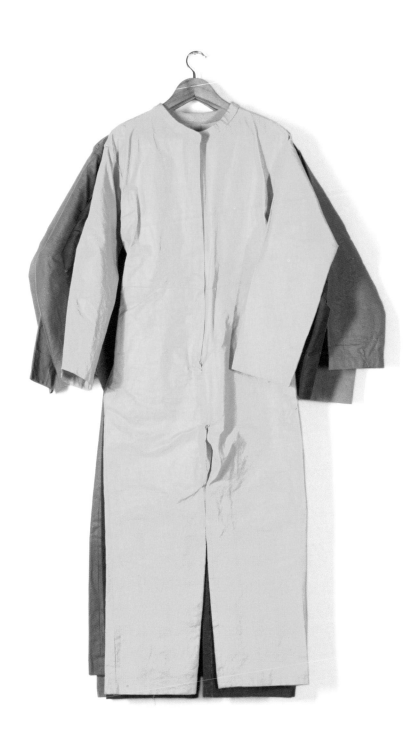

Bernat Daviu

David Dipré
Self Portrait on White Ground

2011
Oil and collaged canvas on board
61 x 47.8 cm

With each painting the aim is to remember and remake the experience of a subject. It is an act of recalling, noting down and inevitably reworking, in order to escape the obvious, easy or derivative. The working process is a balance between defining the subject and stumbling upon unpredicted visual references.

I use portraiture as my main area of exploration, challenged by its rich history and the apparent impossibility of saying something new within this tradition. The aim is always to make visual statements that have the ability to last, and to add something new to the language of painting.

Biography

David Dipré was born in Bexley in 1974. He studied at Camberwell College of Arts London 1991-2 and the University of Central Lancashire 1992-5. His exhibitions include *Open Again* Gallery Fresh London 1997, *Christmas Group Show* Gallery Fresh 1997, *BP Portrait Award* National Portrait Gallery London (touring) 2001, 2002, 2010, *Au Secours* Blackall Studios London 2010, *Group Show* P.H. Gallery (temporary space) London 2010, *Season Ticket* The Old Shoreditch Underground Station London 2011, *Stroke.Edition* Leipzig and European tour 2011/12, *Collectible* Zeitgeist Project Space London 2012 and most recently *Good Times Roll* High Roller Society London 2012.

David Dipré

Nathan Eastwood

A Man after Ilya Repin's Own Heart

2011
Humbrol enamel on MDF
38.6 x 40 cm

A Man after Ilya Repin's Own Heart is part of a series of black and white paintings that focus on observations of my banal daily life in East London. Using my mobile phone I photograph these moments in order to make a painting. At certain moments - making my bed, taking and picking up my kids from school, making dinner and reading the news - I think, 'yes, this is real life'. I paint or read in solitude, while my neighbours listen to music, quarrel, clean their porch and children play in the yard. I place an emphasis on making art within the domestic space, allowing the integration of real life into my painting.

I painted *A Man after Ilya Repin's Own Heart* after watching 'The Art of Russia,' narrated by Andrew Graham-Dixon. He talked about the artist Ilya Repin, explaining that Repin did not believe in having servants but instead did all the manual work around his home himself. Repin's house embodied his intensely political purpose and values, and although rich enough to manage servants he prided himself on the fact that he had none. Repin would proudly shovel snow away from his porch without any help.

Biography

Nathan Eastwood was born in Barrow-in-Furness, Cumbria in 1972. He studied at Kent Institute of Art and Design Canterbury 2001-5 and Byam Shaw School of Art London 2008-9. Group exhibitions include *Occupied Realism* Portman Gallery London 2012, Platform C's *Emergent Art Show* Vyner Street Gallery London 2011, *ArtWorks Open 2010* ArtWorks Project Space (Barbican Arts Group Trust) London and *Dazzleships* Red Room London 2010. He was shortlisted for the *Celeste Art Prize 2007* T2 Old Truman Brewery London and Lyon & Turnbull Galleries Edinburgh Scotland.

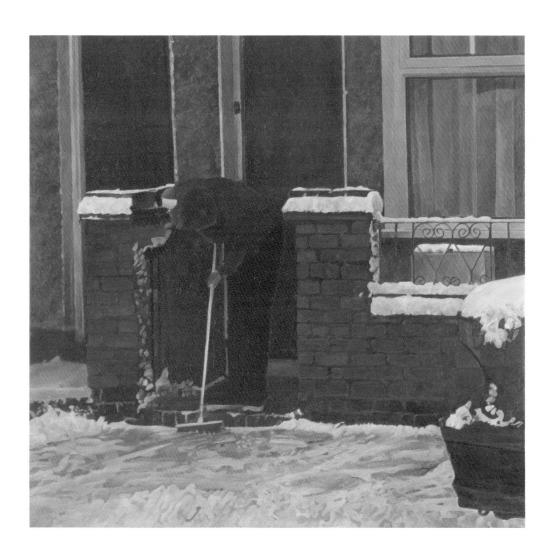

Nathan Eastwood

Liz Elton

Twisted

2012
Acrylic on plastic
Dimensions variable

Twisted is made from the remains of a performance. The painting was prised off the wall, pushed out of the studio, forced to experience the outside world, used to examine the space between itself and its environment. Beaten up, the remains were collected, taken back inside the studio, twisted around a support and hung back on the wall.

Referencing gestures and colour in two paintings by Willem de Kooning (*Two Figures in a Landscape*, 1967 and *Untitled*, 1970), *Twisted* documents its experience of being pushed outside its comfort zone, re-imagining, exploring, trying things out. Altered by its adventure it becomes something new.

Biography

Born in Bristol, Liz Elton studied in London at Wimbledon College of Art (WCA) 2006-9 and Chelsea College of Art and Design (CC) 2011-12. Exhibitions, all London, include *Deutsche Postbank Exhibition* Deutsche Postbank 2007, *Trace* (2 person) WCA 2008, *Liz Elton, 'Inside'* (solo) CC 2010, *Guinea Pig* Triangle Space 2010, *Show* La Ruche 2010, *Open Studios* La Ruche 2010, *Recent Work* Hackney WickED Mother Studios 2011, *Manifesto* Triangle Space 2011, *Foul Perfection* The Castle 2012, *Salon* The Round Chapel 2012, *Words to be looked at* Old Library Pimlico 2012, *Out of Place* CC 2012 and *Group Show* The Bussey Building 2012.

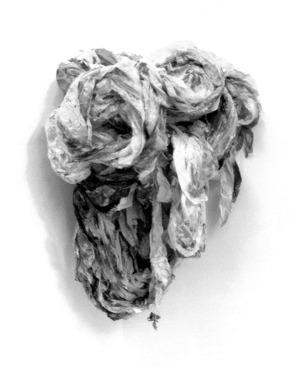

Liz Elton

Oscar Godfrey

Mineral 9

2011
Oil on board
24 x 19.6 cm

My paintings are not exactly figurative but there is an aim to convey the substance/sensation/density of real things or to prompt some sort of sensual recognition.

Mineral 9 is from a series of paintings that were fully composed in preliminary sketches. The colours were premixed and the paintings were executed relatively quickly. I was interested in developing a process that would avoid tentativeness.

Biography

Oscar Godfrey was born in Chester in 1984 and lives and works in Manchester. He studied at Mid Cheshire College 2003-4, followed by Glasgow School of Art 2004-8. His exhibitions include *Macho Minge* (performance) Stour Space London 2010, *Rhizomatic* Departure Gallery London 2010, *Crash Open Salon 2011* Charlie Dutton Gallery London, *Pop Up Povera* (performance) MOCA London 2011, and most recently a solo show *Fat Exotic* CCA Glasgow 2012. He was awarded a Departure Foundation studio in 2012.

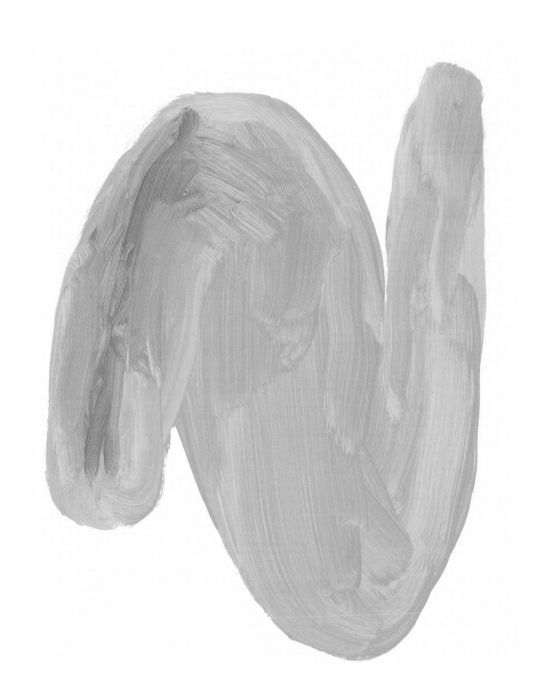

Oscar Godfrey

Vincent Hawkins

The House

2011
Acrylic on canvas
49.7 x 39.5 cm

Things I pick up along the way and put aside will sometimes, when I am working, appear or come back to me in a painting. I will recognise some reference to them in a work. It may seemingly be the most inconsequential incident, accident, object or event. In a painting from about 2007 are our orange and white plastic salad servers...I know it's them. I didn't plan it, they just appeared. It happens like that. Don't fight it, just let it.

Biography

Born in Hertfordshire in 1959, Vincent Hawkins attended Maidstone College of Art 1984-7. Group shows include *Jerwood Drawing Prize* (shortlisted) Jerwood Space London (touring) 2006, *Summer Exhibition* Royal Academy of Arts London 2007, 2008, *Layer Cake* Fabio Tiboni Bologna Italy 2007, *Invisible Cities* Jerwood Space London 2009, *A Sort of Night To The Mind* Herbert Reed Gallery UCA Canterbury 2009 and Artary Gallerie Stuttgart Germany 2011, and in 2012, *The Perfect Nude* The Phoenix Centre Exeter and Wimbledon Space Wimbledon College of Art London, *Five* Gallerie1/52 La Seyne Sur Mer Toulon, *Moveable Feast* Hôtel Sauroy Paris. Was a prizewinner in *John Moores 24* 2006.

Vincent Hawkins

Bé van der Heide

In the Desert

2011
Oil and acrylic on canvas
205 x 165 cm

Bé van der Heide works most of the time in series. She travels, observes, photographs, sketches, then uses the images in her studio to transform them. When the theme exhausts itself, she travels again, sometimes just to the park, to get the inspiration for a new series.

While looking through junk at a local flea market last year she came upon a brown, very faded postcard, depicting images of fighting in the African desert during World War I. This find initiated her *War* series. The painting *In the Desert* is the first one in this series.

Biography

Born in the Netherlands in 1938, Bé van der Heide attended the Academy for Fine Arts Enschede 1956-60. Past projects include: mural within Netherlands Pavilion EXPO 67 World Fair Montreal, guest artist Outer Mongolia Artists' Union Ulaan Bataar 1992. Group shows include *Huit Montrealaises* Soho Gallery New York 1980, *East* Norwich Gallery 1993, *12th Cleveland International Drawing Biennale* Middlesbrough 1996, *400 Women* Shoreditch Town Hall Basement London 2010. Solo exhibitions include *Meditation on Knitting* Centennial Gallery Oakville Ontario 1984, *New Work* Galerie Biervliet Amsterdam 1989, *Insects* Morley Gallery London 1998, *My Real Family?* South Tipperary Arts Centre Clonmel 2006.

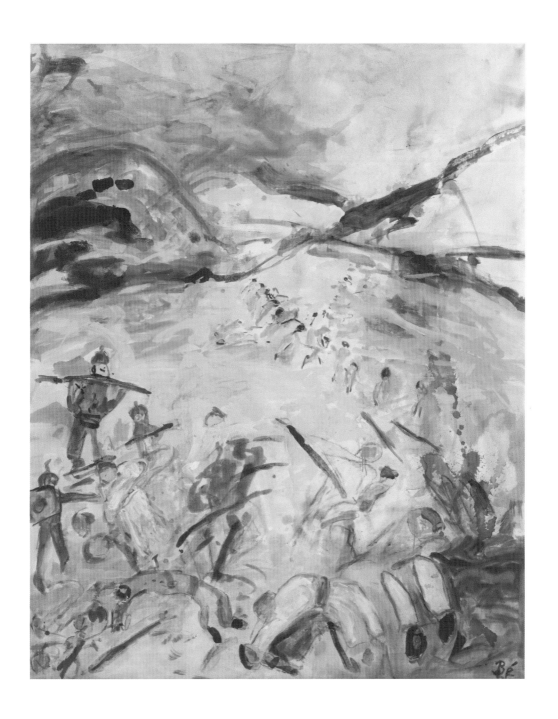

Bé van der Heide

Rae Hicks

Late Summer Mirage

2011
Oil on board
79.5 x 121.5 cm

In *Late Summer Mirage*, a black rectangular form obstructs an orbital road situated on the verge of a forest, bathed in a warm evening light. Inspired by a product photograph in a hobby modellers' catalogue, I have tried to paint it as an almost convincing setting - one that the viewer could imagine themselves into - but that is governed instead by a subconscious half-logic.

In my paintings I aim to give the impression of a fringe-world of displaced forms, which blow through each others' territories and form semi-believable unions, like spare parts drifting in storage. The elements in my pictures are designed not only to recall various forms from life, but also their counterparts as miniatures, relics or sculptures, next to which they exist with equal inconsequence.

They are informed by landscaped environments, typified by themed leisure areas, sports grounds, airports, advertising displays, motorway services and retail parks. Like adverts, these are full of suggestions and hints that in reality I feel are absurd and impossible. The results are locations whose identity as pastoral playgrounds feels at odds with the human habitation they elicit.

Biography

Born in London in 1988, Rae Hicks grew up in Bath, attending City of Bath College 2006-7 and Goldsmiths London 2008-12, including a year at HFBK Hamburg 2010-11. Shows include *Firing the Canon* (self-organised) The Gallery Goldsmiths London 2009, *For Your Eyes Only* Mayfair London 2009, *Komm, Gib Mir Deine Hand* HFBK Hamburg 2010, *Golden Shower* The Golden Pudel Hamburg 2010, *Goldsmiths ♥ HFBK* Amersham Arms London 2010, *Allwork* No.6 Belmont Avenue London 2010, *Gestalten Statt Nur Verwalten* Art School Alliance Studios Hamburg 2011, *New Classics* Elektrohaus Hamburg 2011, *HFBK Jahresausstellung* HFBK Hamburg 2011, *Painthings* Goldsmiths London 2012.

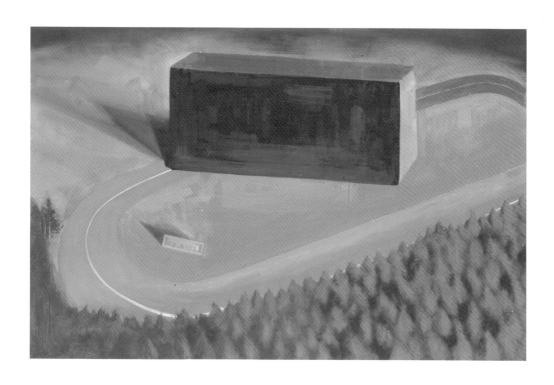

Rae Hicks

John Holland

Home VII

2012
Acrylic paint, bitumen, glitter, photograph, household gloss and pen
on paper
26 x 31.2 cm

The picture is, of course, guided by forces beyond my control or understanding. Higher beings (or my unconscious, or dumb chance) have better ideas than I do, and there is no point in painting something I already know.

It's my job to drag this ridiculous abstract freedom down towards the sadness of things, to try to taint it with the somatic, the still life, towards things with sides, weight, illumination and a space to live in. These facts of being in the world are alluded to, but they're compromised because the paintings remain arrangements of colours and shapes, images, and neither representations of the world or reifications of my thoughts. The process involves hundreds of almost-rational decisions, but no reasons.

The picture must have the illusion of internal necessity, a sense of self-fulfilment, neither over-determined nor merely subjective. Roughly halfway, in fact, between me and the world, with an independent presence, a 'rightness'. Or maybe the right kind of 'wrongness'.

Biography

John Holland attended Braintree College of FE 1987-8, Kent Institute of Art and Design 1988-91. Exhibitions include *Hybrid* Phoenix Arts Brighton 2003, *Drawn* An Lanntair Stornaway 2006, *Dirty Nature* Standpoint Gallery London 2007, *00Nature* Contemporary Project Space London 2008, *The Damned and the Saved* Studio 1.1 London 2008, *Doris* Stedefreund Berlin 2010, *Supernormal* Braziers Park Oxfordshire 2012. Solos include *I'm Trying My Best* 1998 and *Still Trying My Best* 2000 Phoenix Arts Brighton, *What Do You Want?* LAPS Lille 2001, *Ten Things That Help* Phoenix 2002, *Maybe Nature Gets Bored, Too* LAPS 2003, *Food* Hastings School of Art Kent 2007.

John Holland

Kevin Hutcheson

Study

2011
Acrylic and magazine cuttings on paper
25 x 17.5 cm

This piece is a study entitled *Study*, a playful attempt to explore the formal language of painting.

The fragment of collaged imagery in the work offers a glimpse of someone carrying a folder of notes, perhaps going about their studies (the physical scale of the piece reflects an intimacy contained in the act of study).

I sometimes like to work in the library, which can feel similar to going to the studio (or going to see an exhibition). It's a space for contemplation. This piece is a study of such a place.

I find the idea of research as an authentic mode of thought interesting, not only in preparation for a forthcoming event but as an important experience of continued learning in itself. In contrast, the method of painterly mark-making in this work expresses a desire for spontaneity or improvisation - to 'live in the moment', as when creating a study.

Biography

Kevin Hutcheson was born in Glasgow in 1971. He studied at Duncan of Jordanstone College of Art and Design Dundee 1993-7 and Chelsea College of Art and Design London 2001-2. He lives and works in Glasgow. His group exhibitions include *Presence* The Fruitmarket Gallery Edinburgh 2002, *Country Grammar* Gallery of Modern Art Glasgow 2004, *East International* Norwich Gallery 2006, *Learn to Read* Tate Modern London 2007 and *The Associates* Dundee Contemporary Arts 2009. Solo shows include those at Alexandre Pollazzon London 2007, Jacky Strenz Gallery Frankfurt 2008 and Glasgow Project Room 2010.

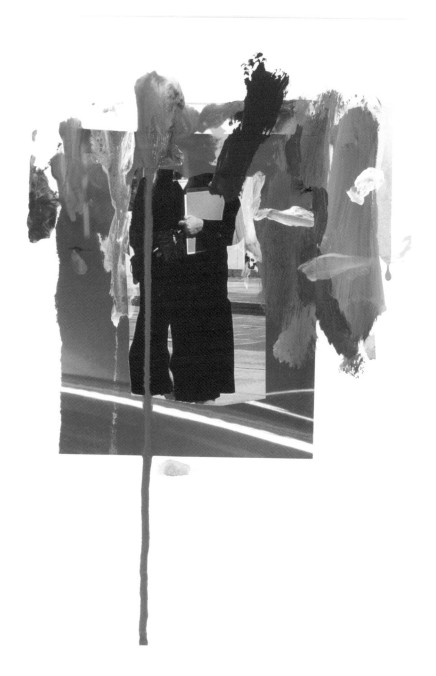

Kevin Hutcheson

Jarik Jongman

Waiting Room (1)

2011
Oil on canvas
120 x 180 cm

I use both my own photographs and anonymous pictures found in flea markets, books, magazines and on the internet as a starting point for my work, which often deals with archetypical imagery.

My latest series of works depicts waiting rooms.

Waiting is something we all do. Almost inevitably, we wait with a purpose. It is a promise that lies in waiting: a reward at the end. Your turn has come, the end of the line, the Kingdom of Heaven perhaps; redemption and eternal life.

Life is uncertain, unpredictable. For this reason, the act of waiting can be quite pleasant. A waiting room is a room where time or life seems suspended. We are temporarily in a situation where we cannot act. And we do not have to. It offers a moment for contemplation, with responsibility temporarily lifted.

We like to think that we make choices in life, decisions made by our free will. But perhaps our sense of control is an illusion. Ultimately there is the fear, the realisation even, that everything is pointless, that all is in vain.

What if waiting is in fact all we are capable of?
Perhaps, then, we should find the reward in the anticipation.

Biography

Born in Amsterdam in 1962, Jarik Jongman attended Arnhem Fine Art Academy 1990-2. He was an assistant to Anselm Kiefer. Exhibitions include *Travelling Light* WW Gallery Venice Biennale 2009, *National Open Art Competition 2010* (joint First Prize) Minerva Theatre Chichester, *Art Star Superstore* WW Gallery London Art Fair 2011, *Afternoon Tea* WW Gallery Venice Biennale 2011, *Pow!* @ Crunch WW Gallery Hay-on-Wye 2011, *A Wake* Momentum Berlin 2011, *The Open West* Gloucester Cathedral 2012 and *All will be explained* Isi Arti Associate Naples 2012. Solos include *Phenomena* Kap Pur Gallery Tilburg NL 2010 and *Hello, Goodbye* WW Gallery London 2010.

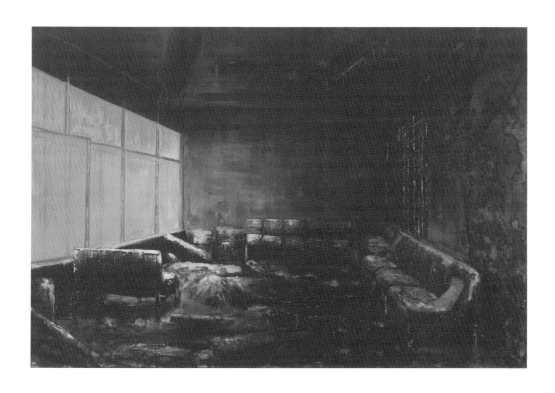

Jarik Jongman

Laura Keeble

"I'd like to teach the world to sing!"

2011
Humbrol enamel paint on found soft drink can
10.1 x 13.5 cm

In 1971 a congregation of multicultural teenagers sang from a hilltop. Their song: a unified call for perfect harmony, equality, housing and Coca-Cola.

In August 2011, on the back of uprisings in the Middle East (Arab Spring), a call to arms was made by a mass congregation of culturally diverse teenagers in the UK. Using social media, rioting spread across London and other cities, including Birmingham and Manchester.

The can was a discovery, a treasure I found on visiting Greenwich the day after the first night of rioting. Laying in the road it was perhaps a relic of the evening's events. I was interested in its memory, the energy it captured. How many people had walked on it? Rioters or the riot police? The symbolic values of equality, harmony and cultural diversity crushed underfoot. It left me questioning if these values are protected or suppressed?

In my practice I try to create a dialectic between the work and the viewer. I am interested in creating a pause, a brief moment in time when a double-take allows for an internal question, a need to assess or understand. I use symbolism and familiarities of the everyday to question what is dictated to us.

Biography

Laura Keeble was born in London in 1977 and attended Essex University Southend-On-Sea 2006-9. Group exhibitions include Lazarides Gallery Newcastle 2007, *Trespass Alliance* Andipa Gallery London 2009, *Dirty Little Secret* Indica Gallery New York 2010, *Skull Cult: History of man* Gottorf Palace Schloss Gottorf State Museum Schleswig-Holstein 2012, *Material matters: The Power of the Medium* East Wing X Courtauld Institute London 2012. Uncommissioned public art installations include *Forgotten Something!?* White Cube Gallery Mason's Yard London 2007, *Christmas Shopping* New Bond Street London 2007 and *Confessional* Royal Exchange Buildings London 2012.

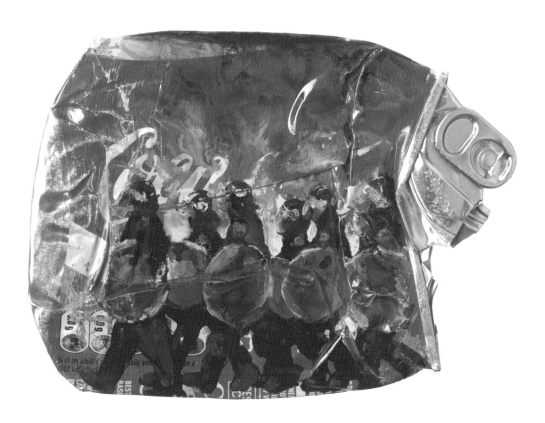

Laura Keeble

Robin Kirsten

Path of Whistlers

2012
Gouache and pencil on cardboard with stickers and tape
45.5 x 38.2 cm

Something around logic to expand transformation possibilities, and philosophical philosophy to measure a maximal; then data of realities given, to excavate in the general. Cosmological seeing at the altering ends of universal form, begins from intuition to procedure with calibrations linked between.

And I, I, I expanding focus to concepts from phenomena - to operate and alter not language, and elucidate on an external - through overlaying perception, then reading all attention new.

These collective contributions, and a reduced and coupled initial something, also understand - but only.

Biography

Robin Kirsten attended Goldsmiths College London 2002-7. Group shows (London unless stated) include (2006) *Shaking Smooth Spaces* Le Générale Paris, *Rag and Bone* Three Colts Gallery; (2007) *Republic* L'Est *Truck Art* @ ART:CONCEPT Paris; (2008) *Fire Red Gas Blue Ghost Green* Sassoon Gallery, *About* AutoItalia, *3 Painters* Gallery Klerkx Milan 2009; (2010) *The Milkplus Bar* (curator) Josh Lilley, *il alla a' lai de l'ail* (curator) Crimes Town, *Tag: From 3 to 45. New London Painting* Brown Gallery. Solos are *On Fear and Reason* Haptic @ La Maison Rouge Paris 2006, *Big Rock Candy Mountain* FormContent 2007, *The Prada Cycle* Gallery Klerkx Milan 2009.

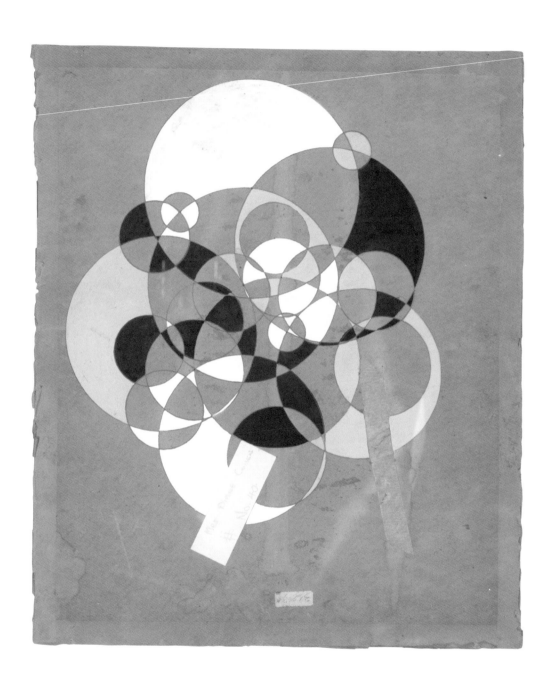

Robin Kirsten

Brendan Lancaster

Wet Casements

2011
Oil on canvas
50 x 70 cm

I'm interested in painting energy that flows, the expansion and compression of form, the diversion of a line, the spatial impressions of colour. Recently there have been many painters exploring the back and forth transition between abstraction and representation, and I see my own work in this context. I like the work to suggest places or situations, but at a remove, not settled, and still using paint in a very physical way that we can respond to physically – the material, texture and scale of the painting.

I let the final state of the painting grow from many detours, dead ends and changes of direction. From all this I'm looking to uncover an image that seems like it's arrived from nowhere, something strange I wasn't expecting.

Biography

Brendan Lancaster was born in Hartlepool in 1968. He studied at Oriel College Oxford (Maths) 1987-90, then at the University of North London (Modernity) 1999-2001. Group exhibitions include *Bristol Art Show* (winner Sponsor's prize) Centrespace Bristol 2008, *Motorcade/Flashparade Open Painting* (First prize) Motorcade/Flashparade Bristol 2011, *Motorcade/Flashparade National Open* 2012, *Other Worlds* Oxford Story Museum 2012, *Six by Four* Motorcade/Flashparade 2012 and *As little as it needs, as much as it can take* Motorcade/Flashparade (self-curated) 2012. His self-curated solo show *New Work* was at Centrespace Bristol 2006.

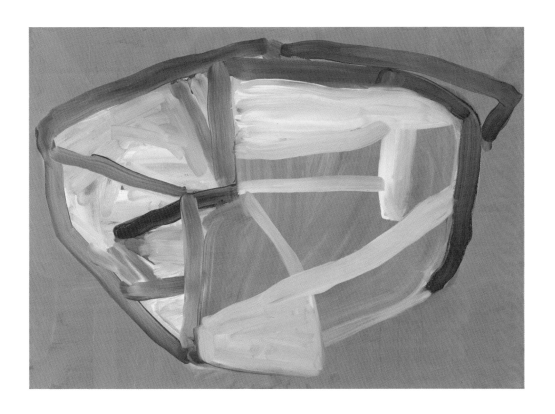

Brendan Lancaster

Laura Lancaster

Untitled

2012
Oil on linen
24 x 30 cm

For me, painting is a transformational process, allowing me to navigate the space between the potency and potential of the subject matter and the stuff of paint itself as a tangible substance. More specifically I am interested in manipulating the meaning of found, anonymous snapshots of strangers, using painting as a method for the unravelling and exploration of the latent humour, pathos and psychological complexity of these objects.

Biography

Born in 1979 in Hartlepool, Laura Lancaster attended Northumbria University 1998-2001 and is based in Newcastle. Group exhibitions include *Micro-Narratives, Tentation des petites réalités* Musée d'Art Moderne de Saint-Étienne Métropole 2008, *Ego Documents* (with residency) Kunstmuseum Bern 2008, *Dawning of an Aspect* Green on Red Gallery Dublin 2009 and *Paintings from England and America* Crisp London 2010. Solo exhibitions include *You are a Movement* Workplace Gallery Gateshead 2010, *Laura Lancaster, New Work* Laing Art Gallery Newcastle 2010, and at The Armory Show New York 2012. Represented in The Government Art Collection and collection of Tyne & Wear Museums.

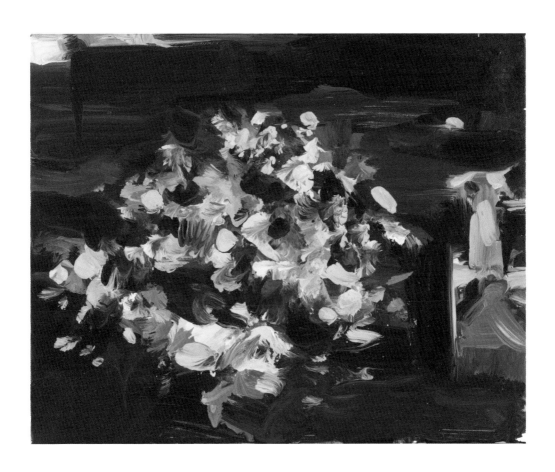

Laura Lancaster

Dominic Lewis

The Auction

2011
Oil glaze on canvas
154 x 114.3 cm

The subject of the auction is Claude Monet's *The Blue House at Zaandam*, completed in 1871. The painting is being sold as part of the Weinberg collection of French painting at Sotheby's on July 11 1957.

My painting attempts to evoke a sense of nostalgia about an historical event, acknowledging the tradition of both history painting and the group portrait. The setting of the auction house, with its drapery and period furniture, housing a painting by one of the most romantic artists in history, raises questions about the contemporary art market and the changing values of art.

The cameras and microphones touch on painting's relationship to the media, whilst the furniture and fashion help to place us in a specific time.

The characters interrelate on different levels, from auctioneer to warehouse attendant to the buying public, from the journalists to the cameramen. All are involved in the shared activity of looking and listening.

Original photographer: Hulton Archive/Collection: Hulton Archive/Getty Images

Biography

Dominic Lewis was born in Brighton in 1975. He studied in London at Chelsea College of Art and Design 1995-8 and The Slade School of Fine Art 1999-2001. He has shown in group exhibitions including *Atelier Something* Springfield House London 2001, *The Second Builders Arms Summer Biennial* The International 3 Manchester 2001, *Gatsby* The New Lansdowne Club London 2002, *14x14* Century Gallery London 2002, *Record Collection* VTO London (and at The International 3 Manchester and Forde Gallery Geneva) 2001, *Barden Boudoirs* (site specific) London 2004, *On Waking* The Octopus Athens 2007, *Polar Union* Denman Arts London 2010.

Dominic Lewis

Peter Liversidge

Proposal for the Jury of the John Moores Painting Prize 2012

2012
Frame, carbon, paper, canvas and acrylic
32.6 x 60 x 3 cm

PROPOSAL FOR THE JURY OF THE JOHN MOORES PAINTING PRIZE 2012,
THE WALKER ART GALLERY, WILLIAM BROWN STREET,
LIVERPOOL, L3 8EL.
6th February 2012.

I propose to commission a painter to paint a copy of this typed
proposal. The painter would be given instruction to complete the
painting on stretched canvas. The second instruction to the painter
would be to paint every last typed letter, starting at the top
left and finishing at the bottom right, so that the painted copy
is as good a likeness of what you are now reading.
The finished painting would be installed to the right of this prop
-osal, exactly 137cm from the floor with 15cm between this, the
typed proposal, and it's painted copy.

Peter Liversidge.

Biography

Born in Lincoln in 1973, Peter Liversidge lives and works in London. His group exhibitions include *Multiplication* (British Council exhibition) Museo de Arte Contemporáneo Universidad de Chile Santiago Chile (touring) 2007, *The Fifth Floor* Tate Liverpool 2008, *Room Collaborators 2* Room London 2010. His solo exhibitions include *Fair Proposals: Art Statements* Art Basel 38 Switzerland 2007, *Proposals for Brussels* Europalia Arts Festival Brussels (with the British Council) 2007, *COMMA 07* Bloomberg Space London 2009, *THE THRILL OF IT ALL* Ingleby Gallery Edinburgh 2009, *Proposals for Cardiff* Chapter Cardiff 2010, *Proposals for Sean Kelly Gallery* Sean Kelly Gallery New York 2011.

Peter Liversidge

Angela Lizoń

Made in Taiwan

2011
Oil on canvas
8.1 x 6.1 cm

I seek out items resonant of my working-class background, never paying more than a couple of pounds for each, and re-invent them within the context of 'Fine Art' painting. I search for the pathos within an ornament, finding intrinsic value and worth within discarded and unvalued objects, plus something a little off-key, trying to bring this out with careful lighting and adjustment of the image on a computer. The resulting photograph then becomes the source image for the painting.

This particular ornament has its own mystery and narrative, from the 'Made in Taiwan' sticker on its head, and its purchase for 29 pence in a charity shop. Who made it and for whom? Did they believe in its artistic value? Who originally bought it? Who threw it out to be finally valued for so little? Is the man holding a rifle, an oar or a fishing rod?

Biography

Angela Lizoń was born in London in 1962. She studied at Bristol Polytechnic 1983-6 then Krakow Academy of Fine Art Poland 1986-7 (scholarship, funders: Polish government, the British Council). Group exhibitions include *The Open West* Gloucester Cathedral 2009, *Exeter Contemporary Open 2009* Phoenix Gallery (Exhibition Award, Audience Choice Award), *Summer Exhibition* Royal Academy of Arts London 2010, *The Threadneedle Prize* Mall Galleries London 2010, *Never Judge...?* Stolen Space Gallery London 2010, *Modern Fabulists* View Gallery Bristol 2011, *Motorcade/Flashparade Open Painting* and *National Open* Bristol 2011. Solo show *Colossal Cats* was at Howard Gardens Gallery CSAD Cardiff 2010 and Prema Uley 2011.

Angela Lizoń

Elizabeth Magill

Sighting

2012
Oil on canvas
168 x 198.1 cm

In this painting a duality emerged between something kind of dark and submerged against something light and ephemeral.

I depicted a perched bird to counteract and balance the weight of the darkness and perhaps allowing the eye to travel up the branches and catch sight of this rare creature. In fact it's beyond rare, as it doesn't exist at all.

Originally I read about this creature in Joyce's *Ulysses* in a sentence that ran *'...a waste land, home of screechowls and the sandblind upupa.'* I was drawn to the comic strangeness of the name 'upupa'.

In reality it's a colourful tangerine bird but during the painting it became white as the work developed so it can be read now as a ghost of a bird...a ghost from a text in a book.

Landscape painting gives me this kind of room to place ideas from many sources in a wider space.

Biography

Born 1959 in Canada, Elizabeth Magill attended Belfast College of Art 1979-82, The Slade London 1982-4. Group shows include *British Art Show 3* (Hayward touring) 1990-1, *0044* PS1 New York (touring) 1999, *Premio Michetti* Fondazione Michetti Italy 2000, *The Glen Dimplex Awards* Irish MOMA Dublin 2001, *Interlude* Douglas Hyde Gallery Dublin 2011. Solos include *New Works* Southampton City Art Gallery 2000, *Recent Paintings* The Hugh Lane Dublin 2002, *Elizabeth Magill* Ikon Birmingham (touring) 2004-5, *Chronicle of Orange* Wilkinson Gallery London 2008, *Green Light Wanes* Towner Eastbourne (touring) 2011, *Land-scape* HITE Collection Seoul Korea 2012. Collections include Ulster Museum and the Government Art Collection.

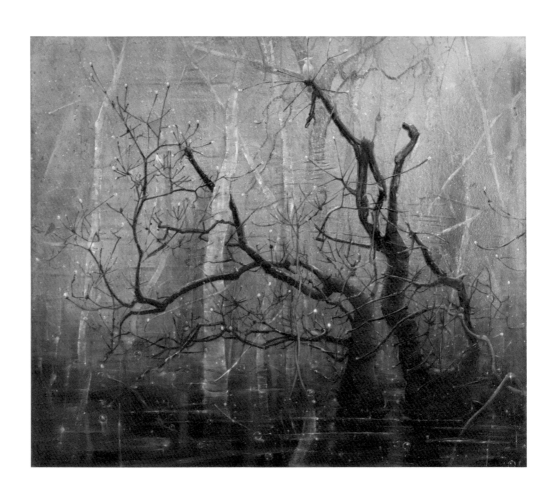

Elizabeth Magill

Danny Markey

Traffic Island in the Snow

2011
Oil on board
23.5 x 29.5 cm

This painting was made when it snowed heavily during the winter before last. Everything outside became very beautiful, especially as night fell and the street lights turned the snow orange and purple and the sky was a deep blue. Yet I was not moved to respond to this until I noticed these street signs at the roundabout lit against the grey-purple snow in the fading afternoon light. I felt an urgent need to put this down in paint.

At the time I did not question this impulse. Now I think this nowhere place almost emptied of subject matter allowed me to make something I could feel was my own. The painting was largely completed outdoors in one quick session. Small alterations were later made in the studio until I thought the painting should be left alone.

Biography

Danny Markey was born in Falmouth in 1965. He studied at Falmouth School of Art in 1983-4 and Camberwell School of Art London 1984-7. Has exhibited with Redfern Gallery London since 1992. Was elected Royal West of England Academician 2001. Group shows include *The London Group* Barbican London 1993 (prizewinner), *Autumn Exhibition* 2001, *Night* 2008, *The Drawing Room* 2008 - all RWA Bristol, *The Discerning Eye* Mall Galleries London 2001, 2002, 2007 (prize, Best Artist from Wales 2007). Second prize, RWS *Sunday Times Watercolour Competition* 2009. Work held in collections of British Museum London and Falmouth Art Gallery.

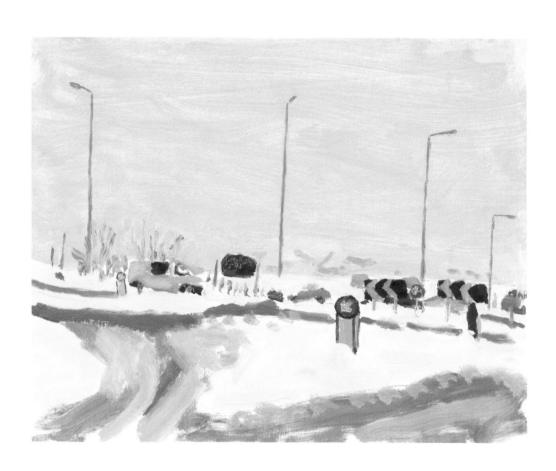

Danny Markey

Enzo Marra

Monet

2011
Oil on canvas
50.2 x 50.5 cm

My painterly work is characterised by elements of history, mythology, surrealism and metamorphosis. I am an artist in my studio, painting artists at work in their studios, each depicted in a manner that conjures up our collective romantic vision of the artist toiling away in a bohemian garret. My subjects are distant, yet attainable, not enhanced, nor superhuman; they are simply artists, like me.

I relate to my subjects as equals, yet my monochrome palette and viscous brushwork somehow mythologises them to an even greater extent than the black and white photographs from which some of the paintings derive.

Each is handled in the same thick impasto and tonal palette, dense portraits of men and women at work, simple yet inspirational. Mythology plays an important part in my work. The framing of artists in their studios is a potent mirror of the hopes and expectations of a million artists, following the exact same path.

This painting was inspired by a 1924-5 Henri Manuel photograph of Claude Monet working in his studio in Giverny.

Biography

Enzo Marra was born in Bournemouth in 1975, studying there at Shelley Park Art College 1993-5, then at the universities of Reading 1995-9 and Brighton 1999-2001. Exhibitions include *Travelling Light* WW Gallery Venice Biennale 2009, *Summer Exhibitionists* and *Is There Anybody There?* WW Gallery London 2009, *The Threadneedle Prize* Mall Galleries London 2010, *GFEST Visual Arts Exhibition* Atrium at Hampstead Town Hall London 2010, *London Art Fair* (Art Projects) WW Gallery 2011, *Afternoon Tea* WW Gallery Venice Biennale 2011, *Anthology* Charlie Smith Gallery London 2011, *The Open West* Gloucester Cathedral 2012. His solo show *Demigods* was at WW Gallery 2011.

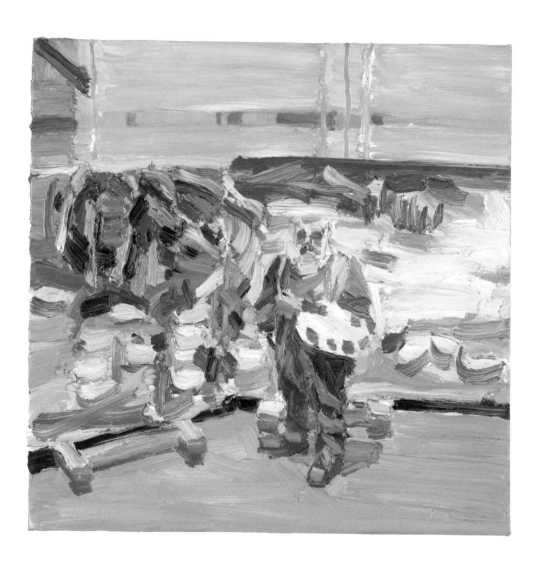

Enzo Marra

Rui Matsunaga

Monkey

2011
Oil on board
34.8 x 29.6 cm

In my work, the enigmatic is fused with a multitude of references from ancient magic to cybernetics in order to lead to a meditative sense of our universal human condition. From another perspective, my work is rooted in the Japanese background of a post nuclear bombed society and its cultural impact in relation to nature and fiction. Inspiration from contemporary Manga, films, mythology and religion reflect an increasingly technological world where a new spirit of mind raises a range of questions about our relationship with nature and the unseen world of the magical and the spiritual.

Biography

Born in Japan in 1968, Rui Matsunaga attended the International Christian University Tokyo 1987-90, London's Central Saint Martins 1996-9 and the Royal Academy Schools 1999-2002. Exhibitions include (2006) *Outdoors* Danielle Arnaud Gallery London, *I'll Be Your Mirror*, Liverpool Biennial; (2007) *Celeste Art Prize* (finalist) T2 Old Truman Brewery London and *Rui Matsunaga -* *Painting and Drawings* (solo) Primo Alonso London; (2008) *I don't speak very much* I-MYU Projects London, *New London School* Mark Moore Gallery Los Angeles, *The Future Can Wait* T1 Old Truman Brewery London; (2011) *Polemically Small* Torrance Art Museum Los Angeles; (2012) *Immortal Nature* Edel Assanti London.

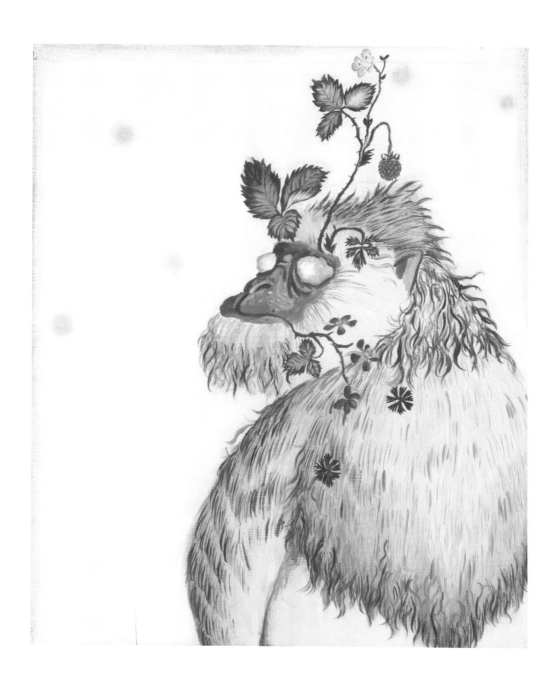

Rui Matsunaga

Onya McCausland

Iron Hill

2011
Earth pigment in acrylic medium on plywood panel and wall
119 x 164 cm

For me, there is something indescribable about finding a pigment in the landscape.
The sources of pigments in the earth are related to the long history of painting.
Iron Hill refers to the material - iron oxide - to the site of the material's origins - a hill
- and to the tradition of British landscape painting.

Old materials carry new meaning and this ochre is made from mine water, a polluting
legacy of the redundant mining industry. The pigment is also the subject of the painting,
and part of the story of the changing condition of the contemporary landscape.

The shape recalls distortions of perspective associated with medieval wall painting
and suggests space beyond the physical surface of the wall. The meeting point between
the two halves of the painting is reminiscent of a horizon line. This illusion is undermined
by the relationship of object and shadow and by the surface of the wall asserting itself
as *present*.

Biography

Born Zennor, Cornwall in 1971, Onya McCausland attended Falmouth School of Art 1991-4 and The Slade London 1997-9, where she is currently Research Assistant. Exhibitions include *Contact* (with Tess Jaray, Rana Begum, Martin Creed) 79a Brick Lane London 2009, *Mark Out II* Meantime Project Space Cheltenham 2010, *London to Cairo* (with Khaled Hafez) Delfina Foundation London 2011. Solos include *English Red Earth* Gloucester Cathedral 2008, *Transitions - Salt Green* Newlyn Gallery Cornwall 2008, *Alentejo Red Earth* Drawing Spaces Lisbon 2009, *White Earth* St Peter's Church Kettle's Yard Cambridge 2010, *Carbon Iron Chalk* Slade London 2011 and *Sited* Millennium Galllery St Ives Cornwall 2012.

Onya McCausland

Dougal McKenzie

Otl's Gift (The Honeymoon of the Mechanical Bride)

2011
Oil and graphite on linen, garment,
graphite/watercolour/collage/digital print on paper
97 x 94 cm

My current work seeks possible meeting points between painting and design (from architecture, to fashion, to graphics). I am interested in surfaces and how they might connect to painting: the sleeve of a 1970s record album, that could be considered as representing the last significant period of the protest song and mass youth demonstration; a graphic designer's layouts and the surrounding political events; a polyester garment that also becomes part of the fabric of the painting itself; each are utilised as source material for this work. I am also interested in painting's dialogue with its own history and with history in its widest sense. The title of this work refers to Otl Aicher, whose designs for the Munich Olympics of 1972 aimed at a highly functional yet friendly 'Rainbow Games', an aspiration undermined by the Palestinian Black September attacks at the Olympic Village. Aicher had also been sympathetic with the White Rose resistance movement against National Socialism, and throughout his life remained committed to Modernism's utopian vision. The garden was an important 'thinking space' for Aicher, particularly when cutting the grass. Late in life, he was tragically killed by a motorist as he crossed the road on his lawn mower.

Biography

Dougal McKenzie, born in Edinburgh in 1968, attended Gray's School of Art Aberdeen 1986-90 and University of Ulster Belfast 1990-1, where he lectures in painting. Recent group shows include *The Double Image* (curator) Golden Thread Gallery Belfast 2007 and *Layers: John Moores Contemporary Painting Prize Show* Seongnam Arts Centre South Korea 2010. 3-person show (with David Crone, Mark McGreevy) FE McWilliam Gallery Banbridge N Ireland forthcoming 2013. Recent solos include *Dunkelbunt* 2009 and *Hot and Cool* 2011 The Third Space Gallery Belfast. Prizewinner *John Moores 23* 2004 and recipient of a major Arts Council of Northern Ireland award 2005.

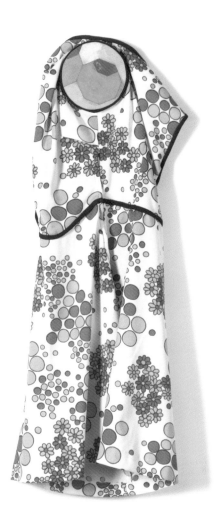

Dougal McKenzie

Damien Meade

Talcum

2011
Oil on linen on board
65.5 x 48.2 cm

As a painting of a sculpture, it is artifice within artifice, but its phenomenology moves beyond this: the inanimate appears reanimated, something uncanny. The actual real collapses into an illusion of the Real, the *other*.

I like how the title *Talcum* traverses notions of the cosmetic and the scatological, how something abject and inert might display a trace of consciousness, vanity, or even perversion.

Biography

Damien Meade was born in 1969 in Limerick, Ireland. Attended DIT Dublin 1987-91, Chelsea College of Art London 1992-3. Artist Fellowship Churchill College Cambridge University (in association with Kettle's Yard) 1994-5. Group shows include (2010) *SV10: Members' Show* Studio Voltaire London, *Super Natural* Charlie Dutton Gallery London, *Be-Head* Andipa Gallery London; (2011) *The Perfect Crime* No.4a Gallery Malvern, *FROM LONDON* (curator) Galería Art Nueve Murcia Spain; (2012) *The Perfect Nude* Wimbledon Space WCA London (touring), *Reason Swings Its Bone* Pesthouse Editions Amsterdam, *SV12: Members' Show* Studio Voltaire, *The Smallest Composite Number* Standpoint Gallery London. Solo show *Damien Meade* Charlie Dutton Gallery 2012.

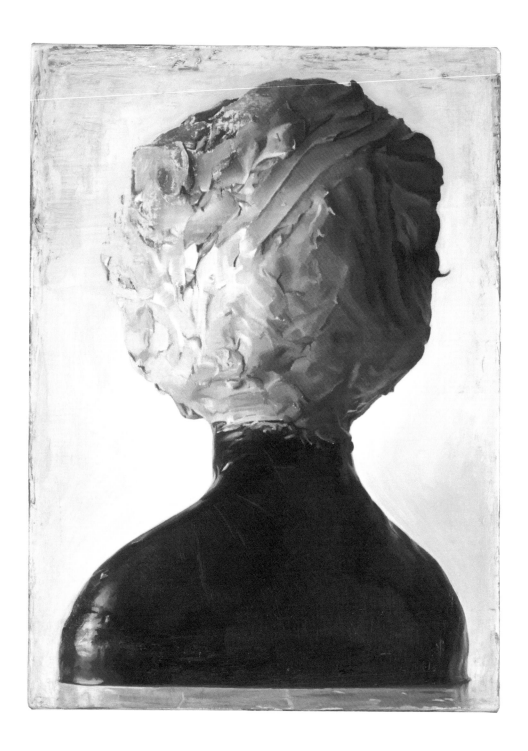

Damien Meade

Sonia Morange

Poncho

2012
Acrylic, ink and pigment on canvas, stitched with thread
244 x 141 cm

This piece is assembled from scraps of painted canvas - colour experiments that are cut and sewn together. As a flattened form demanding a painterly experience and a sewn object made to be worn over one's head, *Poncho* presents a dual purpose.

Akin to the ceremonial robes by which it was partly inspired, it is kept on display when not being worn, enabling two very different forms of exhibition. With neither claiming precedence over the other, its duality is inextricable.

While I am interested in the conversation of painting being both surface and object, these polarities need to be transgressed. The sliced surface and the sewn composition are not meant as iconoclastic gestures but rather to further investigate their aesthetic possibilities. Culminating in an exuberant covering, the work proposes an alternative ritual for painting, a surface to dance in.

Biography

Sonia Morange was born in Paris in 1977 and lives and works in London. She studied at Parsons The New School for Design New York 1996-2000 and Goldsmiths College of Arts London 2005-7. She has participated in various group exhibitions in Los Angeles, New York and London.

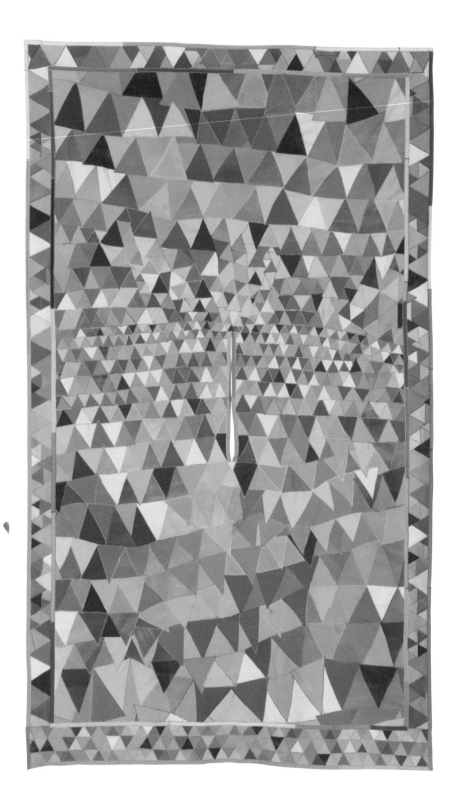

Sonia Morange

Pat O'Connor

Black

2011
Oil, gouache, acrylic, pencil, ink, exercise paper, watercolour paper,
oil paper, card, carbon paper, magazine collage, gesso, canvas,
MDF and plywood
196.5 x 242 cm

I make wall-based assemblages and tableaux from paint, wood, collage and found images, sometimes epic, at other times placed in confined vestibular spaces. The images I appropriate are mainly photographic, often focused on personalised illustrations and printed material from popular culture's history. Using sources from the internet and encyclopedias, to fashion and film, I produce aesthetic disjunctions to explore contemporary issues of politics, history, visual culture and mass media in a less standardised way.

Biography

Pat O'Connor was born in Monaco in 1971. She graduated from the Royal College of Art London in 1996. Group exhibitions include *Salon Nouveau* Engholm Engelhorn Galerie Vienna 2007, *Rotate* Contemporary Art Society London 2009, *PERM WORKS* The Two Jonnys' London 2011 and *SV12: Members' Show* Studio Voltaire London 2012 (winner, Aldeburgh Beach SOUTH LOOKOUT Residency Prize). She collaborated with design company Hit producing *Fast Women and Slow Horses* launched at Publish and be Damned London 2009. Solo shows include *Caragh Thuring & Pat O'Connor* Ashwin Street London 2006 and *Say Sorry for Not Making* Moot Nottingham 2008.

Pat O'Connor

Jay Oliver

Outside Toilet

2011
Acrylic on canvas
25.4 x 35.4 cm

Outside Toilet was painted over several months and re-worked many times. It is from the series *Village* that I have been working on since 2003. The paintings, drawings and photographs in this series are part documentary and part fiction. They are humorous, serious and occasionally nostalgic.

Biography

Jay Oliver was born in Gillingham in 1970. He studied at Kent Institute of Art and Design Maidstone 1988-9 and University of Wales College Newport 1989-92. He is Senior Lecturer in the University of Lincoln's School of Art and Design. His exhibitions include *Singer and Friedlander/Sunday Times Watercolour Competition* Mall Galleries London 1994 and 2001, *Jerwood Drawing Prize* Jerwood Space London (touring) 2004, *Royal West of England Academy Autumn Exhibition* RWA Bristol 2006, *Jerwood Drawing Prize* Jerwood Space (touring) 2008 and *Lynn Painter-Stainers Prize* Painters' Hall London 2008 and 2010.

Jay Oliver

Dan Perfect

Future Sun

2011
Oil and acrylic on linen
183 x 257.5 cm

My paintings are imagined interior or psychological landscapes. They are like stage sets or dramatic scenes from video games; their space doesn't go on forever, and they have hidden rules and parameters. They arise from drawings which are manipulated and re-imagined digitally. I have to reinvest every paint mark with intensity and presence. They aren't direct responses to nature, but are fantasised experiences, a way of bringing the outside world into my studio. They seem quite urban and technological, and there's a strong sense of science fiction in them; a decayed science fiction where tumultuous change and biological entropy intervene. My paintings are full of experimentation and alteration. Everything is partial: masks, costumes, body parts, animals that are human, humans that are animals, things that are taken apart and exploded. Cultural history is rooted in biology but futurologists predict that we may soon be able to transcend our biology - in 50 years you may be able to upload yourself. In my paintings I'm thinking about the nature of what it is to be us in this world right now, and what we might become.

Biography

Dan Perfect was born in London in 1965 and studied there at Chelsea School of Art 1981-3 and St Martin's School of Art 1983-6. Group exhibitions include *Death to the Fascist Insect...* Anthony d'Offay Gallery London 2001, *Beck's Futures* ICA London 2002 (touring), *Exploring Landscape: Eight Views from Britain* Andrea Rosen Gallery New York 2003, *Newspeak: British Art Now* Saatchi Gallery London 2010 (touring). Solo exhibitions include *Dan Perfect: Paintings* Chisenhale Gallery London 2008, *Paintings and Drawings* Road Agent Dallas 2008 and *Dæmonology* Karsten Schubert Gallery London 2010. Collections include the Government Art Collection and Southampton City Art Gallery.

Dan Perfect

Oliver Perkins

DEAD RUBBER

2011
Rabbit skin glue, oil primer and ink on canvas
175 x 123 cm

DEAD RUBBER is a painting that repeats its own structure before being stretched, sized and primed more than it probably needs to be. My work often extends the arbitrary actions at play within a process. This slowing or repeating functions as a tool for abstraction and allows for a porosity to exist within a seemingly defined system. By removing the interface of illusionistic space and promoting the real, the works present themselves as immediate visual proposals. These are works with side doors to alternative avenues of contemplation where relational and formal criteria apply equally. The bold ink lines that happen over the white monochromatic surface fuse the performative gesture and conceptual into one elastic appraisal of space.

Biography

Oliver Perkins was born in Christchurch, New Zealand in 1979. He studied at Canterbury University 1999, Christchurch School of Art and Design 2000-2 and Chelsea School of Art and Design London (with TANZ scholarship 2005). Group shows include *Cory Michael Project* (co-curator) Ada St London 2008, *Jerwood Contemporary Painters* Jerwood Space London 2009 (touring), *What If It's All True, What Then?(part 2)* Mummery+Schnelle London 2011, *You Play the Line, I Play the Sand* (with David Brian Smith) Galerie VidalCuglietta Brussels 2011 and *Big Refrigerator* Hopkinson Cundy Auckland NZ 2012. His recent solo show was *Accordion* Cell Projects London 2011.

Oliver Perkins

Virginia Phongsathorn

Comma (Test Piece for an Eye Break)

2011
Oil on canvas
119 x 147 cm

When making this painting I was thinking about the comma as an indicator of pace and breath, and as a bizarre object - a shape or tool that is so commonly used it is seldom considered as a thing in its own right.

The work is one of a series. It was made with the idea that a picture such as this one, which is easily readable in a graphic sense, would dictate a sense of visual rhythm when punctuating the viewing of a group of paintings that are somewhat more abstracted. It is the swing back and forth between depiction and abstraction, image and shape, that interests me the most in terms of my practice. I enjoy playing with a kind of 'vibe' when painting – giving each picture a particular mood, stance or voice – a voice which is complete with timbre, colloquiality, volume, and singularity.

What I love the most about painting is the scope that it gives me to meddle with the way in which real things are read or understood. On a canvas, a benign, commonplace object can become monumental and vice versa. The complexity of the language of painting is its intrigue.

Biography

Virginia Phongsathorn was born in London in 1984, studing there at Wimbledon School of Art 2003-6 and The Royal College of Art 2006-8. Group exhibitions include *Hans Brinker Painting Prize* (finalist) Amsterdam 2006, *Pentimenti* Permanent Gallery Brighton 2008, *Between Shadows* Cordy House London 2008, *Contested Ground* 176 Gallery Zabludowicz Collection London 2008, *Saatchi 4 New Sensations* The Old Truman Brewery London 2008, *This is the Front Room* Madame Lilies London 2009, *Underfoot* 97-99 Clerkenwell Road London 2010, *Told* Cole Contemporary London 2011. A solo show is at Galerie de l'Angle Paris Autumn 2012.

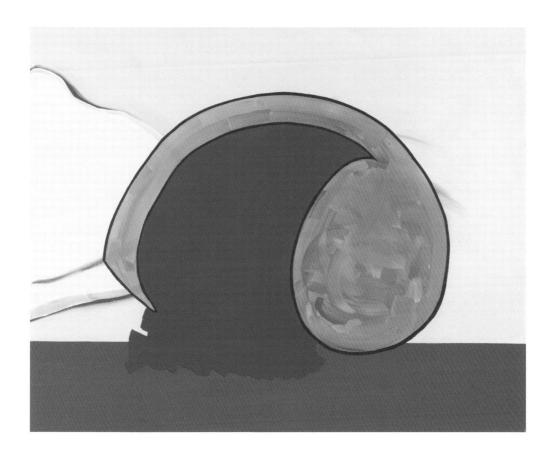

Virginia Phongsathorn

Tom Pitt

Steps, Forest Rec.

2011
Oil on board
60.5 x 91 cm

Steps, Forest Rec. is one of a series of paintings of places around the area where I live in Nottingham. I have painted steps, paths, gates or, broadly, 'ways'. I see each painting as both an obstacle and a way.

I paint on board as it allows me to scrape back and rework. For me the scraping is as much a creative process as a destructive one. The marks left can dictate how the painting progresses.

Biography

Born in Barry, Wales in 1980, Tom Pitt studied sculpture at the University of Wales Institute Cardiff 2000-3. His recent exhibitions were *Tarpey Gallery Open* Tarpey Gallery Castle Donington and *Nottingham Castle Open* Nottingham Castle Art Gallery and Museum 2011.

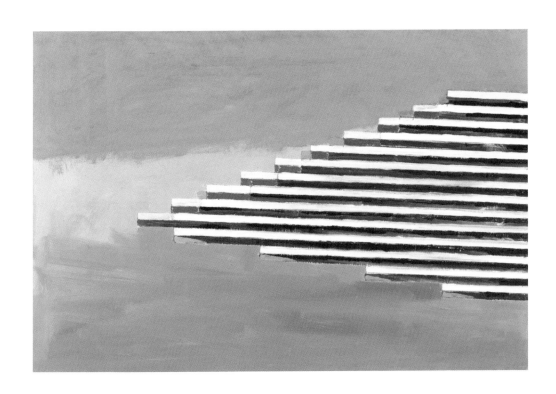

Tom Pitt

Kevin J Pocock

Brutal Façade

2011
Acrylic on canvas
76 x 76 cm

I am fascinated by the thoughts, memories and dreams we carry with us each day. The ones that make us tick. I like to incorporate the universal to represent the very personal. Private thoughts made public. The internal made external.

My work consists of paintings, drawings, video and digital artworks. Most pieces start as a very small, rough, spontaneous sketch. I jot down ideas wherever I might be and later select from these to create a larger piece. This could be a painting on canvas but it could also be a film. The final work is very close in spirit to the original sketch. I enjoy playing with symmetry and asymmetry, and mixing different architectural representations of space - elevation, perspective and parallel projections such as axonometric.

I was brought up in Dorset on the south coast of England. My memories of that landscape and coastline, together with my studies as an architect at Cambridge University, have helped form and direct my work. I love creating new spaces and mixing the artistic with the technical.

I try to achieve an effective simplicity. No more, no less. A quiet contemplation. A private moment.

Biography

Kevin J Pocock was born in Burnham, Buckinghamshire in 1960 and studied architecture at Cambridge University 1978-84. He works in painting, drawing, video and digital media. Exhibitions include *Group Show* New Museum of Contemporary Art Norwich 2005, *Roll On* Stroud House Gallery Stroud 2006, *FourDocs* Channel 4 TV London (online) 2007, *Visions in the Nunnery* Nunnery Gallery London 2008, *Multichannel 2* ArtSway Sway Hampshire 2008, *Abstracta* The Orangerie (Theatre of the Accademia) Rome 2008, *The Open West* Summerfield Gallery Cheltenham 2011, *Group Show* Micaëla Gallery San Francisco 2011, and most recently at the Los Angeles International Art Show in 2012.

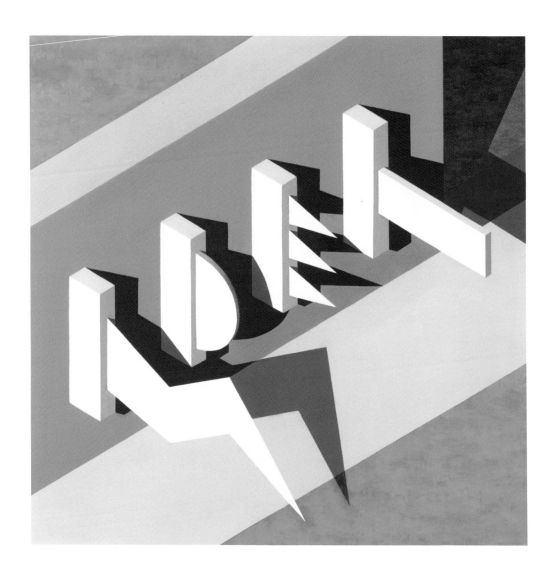

Kevin J Pocock

Sarah Poots

Plaza

2011
Oil on linen
81.5 x 91.5 cm

I am interested in the physical space which marks out our everyday existence. Focusing on that which remains unnoticed and overlooked in my surroundings, it is the elements which section up and divide space that become most important. These fragments provide thresholds or pauses before the infinite sights and spectacles of the city. The paintings are built from the momentary and are defined by the attempt to make still what is constantly changing.

An economy of description is important within the work, to create both a sense of what we know, and of doubt within this recognition. Tipping towards abstraction the work holds onto the recognisable. This highlights a relationship to the world which both interrogates its makeup and holds it at a distance.

Biography

Sarah Poots was born in Co. Down in 1982. She studied at Glasgow School of Art 2002-5 and the Royal Academy Schools London 2007-10. Whilst at the RA she travelled on an exchange to the Leipzig Academy of Art. She undertook a British School at Rome residency in 2010 and received the 2010/11 Chadwell Award at Acme Studios London, where she is based. Shows include *Arrivals* Ormeau Baths Gallery Belfast 2010, *Creekside Open 2011* (selectors Phyllida Barlow and Dexter Dalwood) APT London, *The Desirability of Things* Bearspace London 2011, and *Rose Davey and Sarah Poots* Acme Project Space London 2011.

Sarah Poots

James Ryan

Untitled

2011
Acrylic on checked fabric
100 x 75.2 cm

I employ a process of working with geometric forms that speaks of both painting and the built environment, and of imagery that is found in the graphic arts and crafts, such as animation and textiles. My use of patterned fabrics as painting supports comes from a wish to extend the language and possibilities within the work. On a practical level, the fabric grounds offer a wonky ready-made grid of sorts upon which to work. However, the materiality of the fabric suggests a domestic everydayness that undermines the works' fine art credentials. Another important aspect to my work is the readable layering of forms and intuitive approach to composition that I hope sets up an interesting to-and-fro between perceived rational order and playful spontaneity.

Biography

James Ryan was born in Leeds in 1982. He studied at Northumbria University 2001-4 and the Royal College of Art London 2005-7. Group shows include *Bloomberg New Contemporaries* Cornerhouse Manchester (touring) 2007, *Planatacia x Abstractica* (2-person) Standpoint Gallery London 2009, *Auf der Spitze des Eisbergs* Rod Barton Gallery London 2009, *Jerwood Contemporary Painters* Jerwood Space London (touring) 2010, *Galeria Regresso* Memorial do Rio Grande do Sul Brazil 2011 and *HA HA WHAT DOES THIS REPRESENT?* Standpoint Gallery London 2012. Solo shows are *Parallax* Corn Exchange Gallery Edinburgh 2008, *Paintings* Studio 1.1 London 2009 and *Glitch* Rod Barton Gallery London 2010.

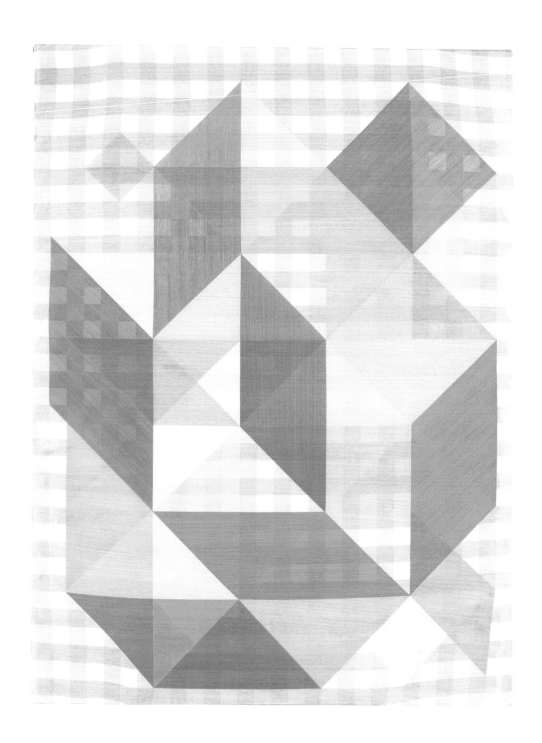

James Ryan

Andrew Seto

Fruit Loop

2012
Oil on canvas
30.1 x 40.4 cm

Fruit Loop is a painting for winter. A grey, low light pervades. The exposed, battered forms and vigorous brushstrokes seek shelter, yet also want to play. A cold moment, captured in a rectangular huddle. Notionally, a landscape. Formally, a painted space with a restless picture plane. Intentionally, a step towards painting's sublime, with a nod to some great paintings of the past.

Biography

Born in Edinburgh, Andrew Seto attended St Martin's School of Art 1987-8, The Slade 1988-92 (scholarship, New York Studio School of Drawing, Painting and Sculpture 1990-1), London College of Communication (2005-7). Group exhibitions include *Jerwood Drawing Prize 2010* Jerwood Space London (touring), *Three* Theodore:Art New York 2011, *Crash Open Salon 2011* Charlie Dutton Gallery London, *SV12: Members' Show* Studio Voltaire London 2012, *There Are No Giants Upstairs* Theodore:Art 2012, *The Threadneedle Prize for Painting and Sculpture* Mall Galleries London 2012. Solos include *New Paintings* London Metropolitan University 2010. He is a trustee of the artists' residency programme, The Florence Trust.

Andrew Seto

André Stitt

The Little Summer of St. Michael

2011
Oil on linen
120 x 120 cm

My recent work reflects a concern with the visual codification of post-colonial landscapes and inhabited futures. Paint is utilised as a synthetic transmitter of experience that reflects the historical uncertainty of place and proposes contemporary genre painting as a transformative medium with redemptive potential. These paintings aspire to a condition of association and evocation rather than representation. As such, they occupy a liminal space that might be defined as ambiguous abstraction. This often reveals itself as a searching out of small, elusive moments and unconscious dilemmas that may implicate us in a larger communal, collective or cosmological narrative.

Biography

Born Belfast in 1958, André Stitt attended Belfast College of Art and Design 1976-80. Currently Professor of Fine Art, Cardiff School of Art and Design. Group shows include *0044* PS1 New York 2000, *Reaction* Venice Biennale 2005, *Navigate* Baltic Gateshead 2005, *Acute Zonal Ultra* The Drawing Centre NY 2006, *Aftermath* Artspace Sydney 2007, *DeathandDaDa* Galerie Lehtinen Berlin 2011. Solos include *Reclamation* Chapter Cardiff 2005, *Substance* Spacex Exeter 2008, *Everbody Knows This Is Nowhere* MCAC Craigavon N Ireland 2009, *Substance II* Golden Thread Belfast 2010, *Spectral Arc* St Paul St. Gallery Auckland NZ 2011. Creative Wales Award 2008 to develop his painting practice.

André Stitt

Trevor Sutton

Irish Painting (for Jack)

2011
Oil on paper and board
94.3 x 63.5 cm

My recent work has returned to the grid: collaged elements on partially painted board make implicit connections with architectural form and detail.

I make non-figurative images that echo the real world but never imitate it, like abstract rhythms making visual music. Paintings have a visible history of colour and gesture but their physicality and flaws become ordered, restrained by the hierarchy of the grid. Colour is intuitive and reactive, encouraging shifting patterns and rhythms between open and divided space, between opaque and transparent sections.

The colours of *Irish Painting (for Jack)* stem from looking at the eccentric façades of local shops, visible from my studio window, whilst on a fellowship in County Mayo, Ireland. After visiting the Giant's Causeway I added a disruptive element into the painting, taking the form of linear asymmetrical diagonals that work in opposition to the grid. The stone formations there seem to defy natural evolution, standing out in a unique and disruptive way from the surrounding landscape. The painting is dedicated to a friend, the artist Jack Smith, who died during its completion.

Biography

Trevor Sutton, born Romford 1948, attended Hornsey College of Art 1967-71. Senior Lecturer, Chelsea College of Art and Design 1973-2000. Artist-in-Residence Kunstgarten Graz Austria 2012. Exhibitions include *Constructed* Sainsbury Centre Norwich 2008, *Black + White* Galleri Weinberger Copenhagen 2010, *Take Two* Noborimachi Space of Art Hiroshima 2010, *Double Vision* Ritter Gallery Klagenfurt 2011, *HA HA WHAT DOES THIS REPRESENT?* Standpoint Gallery London 2012. Solos include *Sutton / Penker* Stadtgalerie Wolfsberg 2007, *Coloured Time* Galerie Sho Tokyo 2007, *Chamber Music* Galerie Schütte Essen 2009, *Paradise Circus* Flowers Central London 2010, *Paintings* Another Function Gallery Tokyo 2010. Prizewinner *John Moores 12* 1980.

Trevor Sutton

Emma Talbot

The Good Terrorists

2012
Acrylic on canvas
165 x 115 cm

In my paintings, I use multiple images to show narrative scenes that are not confined to a linear sequence. In this way, events from different moments in time can coexist and separate ideas can be connected. One of the most interesting challenges in painting, for me, is to make direct descriptions about real life that are convincing, but completely reliant on my own invention without reference to any pre-existing imagery.

In *The Good Terrorists* a house is opened out so that the interior and exterior are visible, together with the activities of the occupants. The title refers to a 1985 novel by Doris Lessing that addressed political agitations and loyalties in a squat.

Themes of political activism are increasingly relevant today, but are not new. My painting describes the use of contemporary technologies, such as the internet and mobile phones, to protest. I also depict rudimentary methods — painting banners, the manufacturing of small bombs from household materials — and symbolic acts, like burning books.

The house is an amalgam of spaces where acts of resistance are both political and personal.

Biography

Born Worcestershire 1969, Emma Talbot attended Birmingham Institute of Art and Design 1988-91, Royal College of Art London 1993-5. Exhibitions include (2010) *Party!* The New Art Gallery Walsall; (2011) *Told* Hales Gallery London, *Outrageous Fortune: Artists Remake the Tarot* Focal Point Gallery Southend (Hayward Touring), *The Life of The Mind* The New Art Gallery, *Me and My Shadow* Kate MacGarry London. Solos include (2010) *Pictures From My Heart* Transition Gallery London; (2011) *A Sheffield Song* BLOC Sheffield, *The Solo Project* Basel, *You Would Cry Too If It Happened To You* Kusseneers Gallery Antwerp. In The Saatchi Collection and David Roberts Collection.

Emma Talbot

Amikam Toren

Armchair Painting – Untitled (The Unthinkable)

2010
Oil on canvas, gilt frame and perspex box
59.4 x 74.5 cm

Armchair Paintings is an ongoing series of paintings. The paintings are ready-made, purchased from cheap market stalls and junk shops. Words and/or phrases are cut out of the canvas and disrupt the continuous space as well as their smug posture. Revived through controlled destruction, they also deal with appropriation and commercial as well as artistic value. The entered painting was purchased in its golden frame, which I chose to keep. The phrase 'The Unthinkable' was originally found as graffiti placed on a wall of a disused pub in the vicinity of my home in east London.

Biography

Born in 1945 in Israel, Amikam Toren's group exhibitions since 1967 include *British Art Show 5* Edinburgh (touring) 2000, *Live in Your Head: Concept and Experiment in Britain, 1965-75* Whitechapel Gallery London (touring) 2000, *British Subjects 1948-2000* Neuberger Museum of Art NY 2009, *No New Thing Under the Sun* Royal Academy London 2010, *The London Open* Whitechapel 2012, *The 4th Guangzhou Triennial* China 2012. Solos include *Amikam Toren, John Frankland* Matt's Gallery London 2005, *Amikam Toren - Carrots & Refreshments* Noga Gallery Tel Aviv 2009, and several at Anthony Reynolds Gallery London, most recently *Moving in the Right Direction* 2012.

Amikam Toren

Matt Welch

Painting of IKEA shelf brackets arranged in such a way as to signify towards IKEA founder Ingvar Kamprad's involvement with Nazism and Swedish Nationalism, distracted by varying levels of perspectival depth, variations in colour and visually dominated by some form of unknown dark oval in the background

2011
Oil on linen stretched over board
34.5 x 24.5 cm

Painting is concerned with the order of images. It is trans-historical in that each painting made is simultaneously the first painting made and another painting made. When technology and communication have reached their pseudo-logical conclusions in the present, I find it playful and perhaps reckless, in parallel with my theoretical concerns, to ask myself, *'What happens when I make a painting now?'*

This painting in particular tries to understand how we unearth and align histories. A consensual arrangement is enacted between the painting and its title, questioning our use of language in relation to things both physically present and historical. The childish and conspiratorial nature of using a set of shelf brackets to make a swastika is a way of thinking about how we use and interpret cultural and political information from the past when it is uncovered and may affect us at a material level in the present. Making a painting about this act was a way for me to monumentalize it and enter it into a conversation with history.

Biography

Matt Welch was born in Liverpool in 1988. He studied painting at Wimbledon College of Art London 2007-10 and is currently a Director of The Royal Standard in Liverpool. His group exhibitions and projects include *The Saatchi Gallery/Channel 4 New Sensations Prize* 2010, *Q-Art London Presents* APT Gallery London 2010, *The Dharma Collective: AND, OR, NOT* (residency, collaboration with Laurence Alan Price) Made in Goldsmiths Gallery London 2011, *AGORA* Tooting Market London 2012 and *FAVELA!* (curator, with Elizabeth Murphy) The Royal Standard Liverpool 2012.

Matt Welch

Ian Whittlesea

Studio Painting - Agnes Martin

2011
Acrylic on canvas
35.9 x 92 cm

The painting shows the address of the American artist and mystic Agnes Martin. It is one of an ongoing series begun in 1995 and collectively called *Studio Paintings*. Using white paint on a dark ground, each canvas names the place where an artist or writer worked.

These paintings do not attempt to tune the rooms in which they hang to the pitch of the place whose address they depict. Instead, they simply use their presence to coerce from the experience of the space a subtle shift, so that that experience might transcend its own location.

Whittlesea's paintings do not demand contemplation. At a certain stage they even become quite irrelevant as, having noted their intent, one ruminates on the spaces, charged with a magical possibility.

Juan Cruz, Art Monthly, Issue 195: April 1996.

Biography

Ian Whittlesea was born in Isleworth in 1967. He studied at Chelsea College of Art 1987-90 and the Royal College of Art 1990-2. Group shows include *Life/Live* Paris and Lisbon 1996 and *We are Grammar* Pratt Manhattan Gallery New York 2011. His first solo show was at Cairn Gallery Nailsworth (now in Pittenweem Scotland); he continues to show there. Other solos include Cleveland London 1997, The Jerwood Space London 2003 and PayneShurvell London 2011. His books include a transimile of Yves Klein's *The Foundations of Judo* 2009, with related events at Tate Modern, and *Mazdaznan Health & Breath Culture* 2012.

3-5 COENTIES SLIP, NEW YORK

Ian Whittlesea

Thomas M Wright

Inherent Omniscience (Second Version)

2011
Oil on board
24 x 20 cm

Inherent Omniscience (Second Version) is a painting of an anthropomorphised letter 'I'. It is both the 'I' of the Institution and that of the Individual. The first work in this series, a drawing, has been placed within Foucault's book, *Discipline and Punish: The Birth of the Prison* in the Study at Nottingham Contemporary.

Biography

Thomas M Wright was born in Nottingham in 1979. He studied at Liverpool School of Art and Design, Liverpool John Moores University 1998-2001 and Goldsmiths College London 2003-4. In 2006 he curated *Seeking Tacit Utopias* at the Surface Gallery Nottingham and in 2010 was awarded the Grand Prize at the *Nottingham Castle Open*. His recent exhibitions include *Dark Matter* The Sunday Painter London 2010, two sideshows within the *British Art Show* in Nottingham 2010 (*Reunion* Oldknows Factory and *Wunderkammer* The Art Organisation), *The Bookmark Project* Nottingham Contemporary 2011, and *Geoff Diego Litherland & Thomas M Wright* Tarpey Gallery Castle Donington 2012.

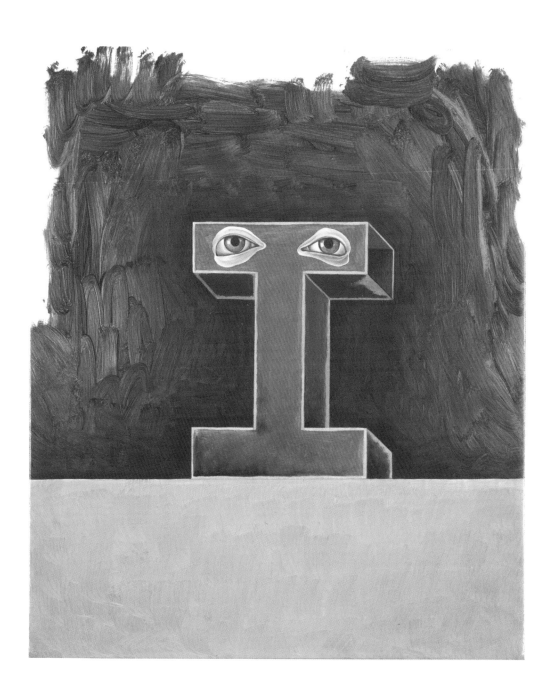

Thomas M Wright

Index of artists

National Museums Liverpool cannot be held responsible for the content of external websites

Eve Ackroyd
www.eveackroyd.com

Henny Acloque
Courtesy of Ceri Hand Gallery
Ceri Hand Gallery Project Space
71 Monmouth Street
Covent Garden
London
WC2H 9DG
info@cerihand.co.uk
www.cerihand.co.uk

Kelly Best
www.kellybest.co.uk

Biggs & Collings
Toby Clarke
Vigo Gallery
1st Floor
22 Old Bond Street
London
W1S 4PY
emmabiggsandmatthewcollings.net

Katrina Blannin
www.katrinablannin.com

James Bloomfield
www.jamesbloomfield.co.uk

Hannah Brown
www.hannahbrown.info

Jane Bustin
www.janebustin.com

Graham Chorlton
g.chorlton@coventry.ac.uk
www.crossgallery.ie

Wayne Clough
wayneclough@hotmail.com
www.wayneclough.com

Julie Cockburn
Flowers Gallery
82 Kingsland Road
London
E2 8DP

Print Sales
The Photographers' Gallery
16-18 Ramilles Street
London
W1F 7LW
www.juliecockburn.com

Paul Collinson
www.englandsfavouritelandscape.co.uk

Andrew Cranston
Hamish Morrison
Hamish Morrison Galerie
Friedrichstrasse 232
10969 Berlin
Germany
www.hamishmorrison.com/en/
Artists/Andrew-Cranston.html

Theo Cuff
Studio 76
Spike Island
133 Cumberland Road
Bristol
BS1 6UX
contact@theocuff.co.uk

Cullinan Richards
Andrea Sassi
dispari&dispari project
Via Vincenzo Monti
25 – 42100
Reggio Emilia
Italy
www.cullinanrichardscollapse.com
www.cullinanrichards.com

Bernat Daviu
www.royalwaterbasedoilsociety.org

David Dipré
duplo@talk21.com
daviddipre.blogspot.co.uk

Nathan Eastwood
nathan.eastwood@hotmail.com
www.neastwood.com

Liz Elton
www.lizelton.com

Oscar Godfrey
oscargodfrey@gmail.com

Vincent Hawkins
www.vincenthawkins.blogspot.co.uk

Bé van der Heide
Park Studios
34 Scarborough Road
London
N4 4LT
be@bevanderheide.com
www.bevanderheide.com

Rae Hicks
raehicks@rocketmail.com
cargocollective.com/raehicks

John Holland
johncgholland@yahoo.co.uk

Kevin Hutcheson
Glasgow Independent Studio
4th Floor, Trongate 103
Glasgow
G1 5HD
kevinhutcheson@yahoo.com

Jarik Jongman
WW Gallery
34/35 Hatton Garden
Clerkenwell
London
EC1N 8DX

Kap Pur Gallery
Korvelseweg 151
5025 JD Tilburg
Netherlands
www.jarikjongman.nl

Laura Keeble
www.laurakeeble.com

Robin Kirsten
robin@hotelbellville.org.uk
robinkirsten.blogspot.co.uk

Brendan Lancaster
brendanlancaster@gmail.com
www.brendanlancaster.com

Laura Lancaster
Workplace Gallery
The Old Post Office
19/21 West Street
Gateshead
Tyne & Wear
NE8 1AD
info@workplacegallery.co.uk

Ian Law
Laura Bartlett Gallery
10 Northington Street
London
WC1N 2JG
020 7404 9251
mail@laurabartlettgallery.com
www.ianlaw.org

Rodeo Gallery
Yeni Hayat Apart. // Sıraserviler No:49 D:1
34437 Taksim
Istanbul TR
+90 212 2935800
info@rodeo-gallery.com

Dominic Lewis
515 Battersea Park Road
London
SW11 3BN
lewisdom@gmail.com

Peter Liversidge
Ingleby Gallery
15 Calton Road
Edinburgh
EH8 8DL
0131 556 4441
info@inglebygallery.com
www.inglebygallery.com

Angela Lizoń
Coates and Scarry
PO Box 3098
Bristol
BS4 9FU
www.angelalizon.com

Elizabeth Magill
Wilkinson Gallery
50-60 Vyner Street
London
E2 9DQ

Kerlin Gallery
Anne's Lane
South Anne Street
Dublin 2
Ireland
www.elizabethmagill.com

Danny Markey
Richard Selby
Redfern Gallery
20 Cork Street
London
W1S 3HL
020 7734 1732
art@redfern-gallery.com
www.redfern-gallery.com

Enzo Marra
WW Gallery
30 Queensdown Road
London
E5 8NN
www.wilsonwilliamsgallery.com

Rui Matsunaga
www.ruimatsunaga.com

Onya McCausland
www.onyamccausland.co.uk

Dougal McKenzie
Hugh Mulholland, Director
the third space gallery
1 Minds Way
Belfast
BT9 6PU
Northern Ireland
hugh@thethirdspacegallery.com
www.thethirdspacegallery.com/mckenzie.html

Damien Meade
www.damienmeade.com

Sonia Morange
sonia.morange@gmail.com
www.soniamorange.com

Stephen Nicholas
contact@stephennicholas.org
www.stephennicholas.org

Pat O'Connor
patoconnorstudio@hotmail.co.uk

Jay Oliver
www.jayoliver.co.uk

Dan Perfect
www.danperfect.co.uk

Oliver Perkins
www.oliverperkins.net

Virginia Phongsathorn
www.virginiaphongsathorn.com

Sarah Pickstone
Cubitt Studios
8 Angel Mews
London
N1 9HH
sarah.pickstone@virgin.net
www.sarahpickstone.co.uk

Tom Pitt
www.tompitt.net

Kevin J Pocock
k@kjpocock.com
www.kjpocock.com

Sarah Poots
sarahpoots@hotmail.co.uk
www.sarahpoots.com

Narbi Price
Dealer (for Mainland Europe only)
Sebastiano Dell'Arte
GalleriaSIX
Via Filippino Lippi, 12
20133
Milan
Italy
info@narbiprice.co.uk
www.narbiprice.co.uk

James Ryan
Rod Barton Gallery
One Paget Street
London
EC1V 7PA
info@rodbarton.com
www.rodbarton.com
www.jamesryanart.co.uk

Andrew Seto
info@andrewseto.com
www.andrewseto.com

André Stitt
www.andrestitt.com
www.warningart.com

Trevor Sutton
trevor@carolrobertson.net
www.trevorsutton.com

Emma Talbot
emmatalbot01@yahoo.com

Amikam Toren
Anthony Reynolds Gallery
60 Great Marlborough Street
London
W1F 7BG
www.anthonyreynolds.com

Matt Welch
mattwelchcontact@gmail.com
www.bepartofsomethingspecial.com

Ian Whittlesea
Marlborough Contemporary
6 Albemarle Street
London
W1S 4BY
www.marlboroughcontemporary.com

Thomas M Wright
www.thomasmwright.co.uk

John Moores
Painting Prize
China 2012

Lewis Biggs

Michael Craig-Martin

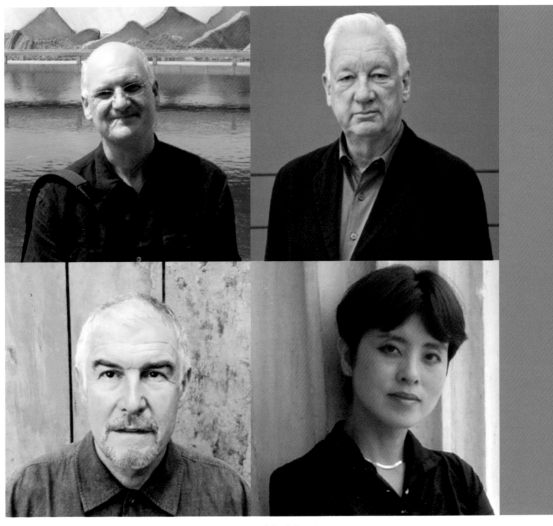

Tony Bevan

Yu Hong

The jury

Liu Xiaodong

Ding Yi

Lewis Biggs
Artistic Director

Tony Bevan
Artist

Michael Craig-Martin
Artist, Art Educator

Yu Hong
Artist

Liu Xiaodong
Artist

Ding Yi
Artist

Preface

By Wang DaWei
Dean, College of Fine Arts, Shanghai University
Vice Chairman, Shanghai Artists Association

It has been two years since the beginning of the first John Moores Painting Prize China.

That exhibition, in 2010, involved more than 1,100 artists from 11 cities in China. This year, the numbers have doubled. There are more than 2,200 artists from 26 cities. Such dramatic growth indicates, quite clearly, the major influence of the John Moores Painting Prize, and the public's resounding approval of it.

The selection mechanism of the John Moores Painting Prize has set a very good example for the healthy development of Chinese contemporary painting. The selection process requires that the jury for every Prize should be different. This ensures that the artistic style of every competition will be different, making it harder for the candidates to predict the jurors' preferences. This prevents uniformity in artists' works and encourages diversity in their painting styles. Furthermore, compared with similar painting prizes in China, the John Moores has a quite different starting point in selecting the winners. While other painting prizes in China focus on artists' names and reputations, the John Moores instead selects artists with the greatest potential. The five winners of the previous John Moores Painting Prize China have all been well received both in China and overseas, producing numerous works which met with widespread approval. I have to say that finding new artists with such strong potential is a mark of the success of the Prize's selection process.

With their different goals and starting points, the selection standards and approaches of the Chinese Prize and its British counterpart differ. The Chinese approach encourages the personal opinions of the jurors. In the British selection process, discussion between the jurors is valued, however the discussion is not just an evaluation of the works themselves, but is also a consideration of the jurors' academic views. Particularly with regard to selecting the top award, the British Prize's jurors put more emphasis on the anonymous artist's statement about his or her work, so that they can judge the full potential and capacity of the artist. So, it is clear that the overall process of the John Moores Painting Prize has brought us enlightenment and inspiration beyond the prize itself.

Together with the John Moores Painting Prize, this year the new John Moores Critics' Award is being staged by the International Association of Art Critics, Liverpool John Moores University and Shanghai University. Both the British and Chinese jurors have given their artistic opinions on the Chinese finalists' work, and it is the first time that the Chinese art community has cooperated with international colleagues to hold an art critics' award based around works from such a painting prize.

2012 sees the second John Moores Painting Prize China, the first being held in Shanghai in 2010. I hope that in 2014, with the efforts of both the British and Chinese juries, the Prize will become a significant competition that continues to give impetus to Chinese contemporary painting. An old Chinese saying goes, '*Tao gave birth to the One; the One gave birth successively to two things, three things, up to ten thousand.*' I believe that by 2014, with the cumulative efforts of three competitions, the John Moores Painting Prize China will continue to mature, grow and prosper.

I want to express my heartfelt thanks for the support of the John Moores Liverpool Exhibition Trust, and Lewis Biggs' wisdom and direction. Also, the jurors Michael, Tony, Ding Yi, Liu Xiaodong and Yu Hong have demonstrated professionalism and absolute commitment to the art. They have all made very deep impressions and I want to express my sincerest thanks to them for their efforts. In addition, I want to thank the Shanghai Oil Painting and Sculpture Institute. Their beautiful Museum has enhanced the exhibition of the John Moores Painting Prize China and has permitted the citizens of Shanghai to share the joy and happiness of the artists' success.

Preface two

By Lewis Biggs
Trustee, John Moores Liverpool Exhibition Trust
Chairman of the Jurors, John Moores Painting Prize China 2012

Before the closing date for submissions in March, I visited several art academies in different provinces of China to promote the John Moores Painting Prize China. One question that came up again and again was 'What will the judges be looking for?'

I was a little surprised by this question (the first time, at least) although I shouldn't have been. It comes from a view of culture as being a response to consumer demand. When we go to the shops, very often we are looking for something particular that we need, and we go on looking until we find the thing that will answer that need precisely. But it's also possible to go shopping even when we have no specific needs to fulfill. At those times, maybe we find we want to buy something we didn't know we wanted. This is when shopping becomes a cultural form.

A painting starts life as an object that might (or might not) answer an existing need and be sold in the market. A painting may also become art (enter culture) through contributing to a conversation about ideas – a different market from that of objects. Ideas confer value through their novelty, topicality or quality. So a painting might provoke discussion and become art because the idea it expresses is original, or because it is particularly relevant for our time, or because while being traditional it is expressed better than ever before. What I want from culture is to have an experience I haven't had before – to learn something I didn't know. Culture is so powerful because it creates needs we didn't know we had.

So when we started judging the entries for the John Moores Painting Prize China, I was reminded of this question – what was I looking for? Art dealers select art that they believe they can sell; museum curators select art that they think answers a need in the cultural market. But the job of the juror, who is part of a selection panel in an open painting prize, is a little different again from these. The range of paintings submitted is very diverse, and the five judges will differ from each other over which kind of paintings they find most exciting, even though they may all agree as to which is the best painting of any particular kind. So the – immensely pleasurable – work of the judge is not only to listen to the different voices of the paintings but also to learn from the different opinions of the other judges.

With some judges from China and some from the UK, there is much to learn on both sides, and I want to thank my fellow judges for their expertise, their insights, and their honesty in evaluating and discussing the paintings, and their readiness to give the benefit of any doubts to the art rather than to their own critique. But the important thing for all of us was to allow the art to speak, and for us to listen carefully to originality, or topicality or quality - to discover something that we did not already know.

The five paintings that are being recognised with a John Moores Painting Prize China award were selected without the judges knowing who the painters were, as has always been the case since the first John Moores competition in Liverpool in 1957. They are examples of very different ways of painting, very different ways of looking at the world. And the exhibition of 64 of the best paintings (selected from the 2,208 submissions) is even more diverse, showing something of the variety of ways in which painting is now being practised in China. In addition to 'discovering' the best paintings from the entries, we - the judges - looked forward to discovering who painted them.

I congratulate and thank each one of them for giving me a new experience, and adding something fresh to the culture of our time.

On behalf of the John Moores Liverpool Exhibition Trust I would like to offer my sincere and appreciative thanks to Dean Wang DaWei and Professor Ling Min, of the College of Fine Arts, Shanghai University, who have carried out an extraordinary achievement in promoting and implementing the John Moores Painting Prize China. The success of the competition has been proven through the subsequent careers of the 2010 prizewinners, and I am confident that the painters of the winning entries in 2012 will receive the same attention and impetus to their careers as was true the first time round.

I would also like to thank Torsten Hendricks and his colleagues at IFAS China, the Fine Art Logistics company. The sponsorship of John Moores Painting Prize China by IFAS has been immensely valuable to the organisers, and demonstrates the progressive values of the company in looking to the next generation of successful artists in China. We are also

most grateful for the support of the British Council, which has helped to further extend the developing relationship between painters in China and the UK in the spirit of cultural exchange.

And we acknowledge with thanks that the staff and members of the Shanghai Oil Painting and Sculpture Institute have agreed to the use of their Museum for the John Moores Painting Prize China exhibition of paintings. The traditions of the institution together with the fine building itself provide excellent conditions in which to exhibit the best in contemporary painting from around all of China.

First prizewinner
Nie Zhengjie

Prizewinners
Zhang Aicun
Zheng Jiang
Hu Wenlong
Pu Yingwei

聶正杰

Nie Zhengjie

存在
Being

2011
Oil on canvas
200 x 250 cm

I feel migrant workers have been much misrepresented. They too live and love. Their lives are not simply about mere existence - they represent a vital life force. They devote their lives to the development of the city and are the connection between the city and the countryside. The growth of the city can't continue without them; it absorbs them, changing them as well. They have dreams as high as these high-rises, despite being seen as just flesh and bone, as sightseeing objects for the city's tourists. Standing among the crowds, in the busy streets, playing vulgar music on their cell-phones, they are alienated from the city's prosperity. In their spare time, they like playing cards, laughing and grinning with browned teeth and will happily fight their landlord over a five cent discrepancy. They can be so loud that the whole street can hear them. They can also be seen living, thriving and loving their life away.

Biography

Nie Zhengjie was born in Yunnan in 1982. He studied in the Oil Painting Department, College of Arts, Chongqing University 2002-6, and now lives and teaches in Chongqing. Exhibitions are *Singapore International Art Fair* 2006, 2008, 2009, *Shanghai Youth Biennial* 2007, *China - The New Generation of Artists* Museo Della Permanente Milan 2008, *The 1st Chongqing Biennial* 2009, *Chengdu International Biennial* 2009, *The 1st National Youth Artists Nomination Exhibition* Chengdu 2011, *Chengdu Excellence Award* 2011, China-Japan-Korean BESETO Art Festival Tokyo. He participated in the 12th World Chinese Art Conference Hong Kong 2010.

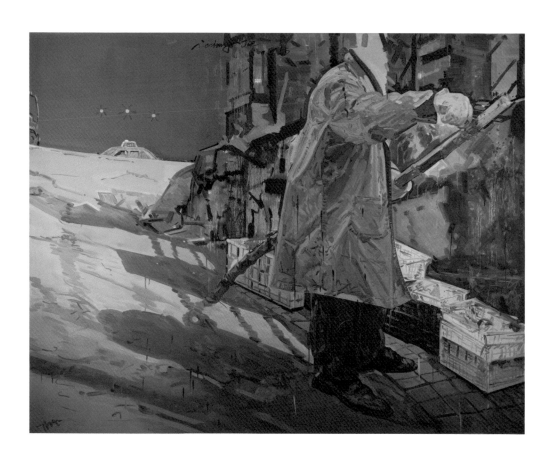

Nie Zhengjie

张媛邨
Zhang Aicun

妆 No.2
Make-up No.2

2011
Acrylic on canvas
150 x 150 cm

Make-up is indispensable for women. Modern city women have to wear all kinds of make-up every day. Make-up of varying qualities and prices on the market distinguishes women of different classes. Some people may buy fake brands with which to adorn themselves. Society today is full of the true and false, the genuine and the fake. Different people play different roles in society.

Biography

Zhang Aicun was born in Yangzhou, Jiangsu in 1976. She studied at Xi'an Academy of Fine Arts (Handicraft Major) 1996-8, (Masters) 2006-9. Exhibitions include *Xi'an Contemporary Youth Art Exhibition* Xi'an 2001, *China Still Life Oil Painting Exhibition* Beijing 2004, *Shanxi Youth Art Exhibition* Xi'an 2004, *Dream of the Tang Dynasty* Xi'an 2005, *Back to the Soviet* Fangyin Gallery Beijing 2007, *Xi'an Literature Exhibition* Xi'an 2007, *Sugar-Zhang Aicun* (solo) Liao Cabinet No.17 Beijing 2008, *'Memories' 10 Years of Contemporary Art in Xi'an* Xi'an 2009, *Relation* Xi'an 2009, *Fine Collections from the End of the South Youth Art Exhibition* Xi'an 2010, *'My People, My Homeland' National Oil Painting Exhibition* Beijing Xi'an 2010.

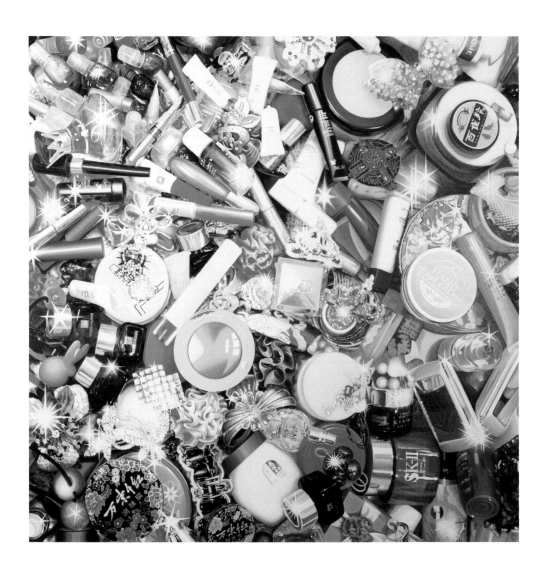

Zhang Aicun

郑江

Zheng Jiang

等待

Waiting

2011
Oil on canvas
95 x 200 cm

We are going through an era of rapid and relentless economic development, but that process of development is also the cause of a 'vanishing'. We have lost much of great cultural value, whilst neglecting much that is inherently beautiful in the process. The emptiness brought about by this vanishing is a faint ache. This painting is inspired by begonia flower patterns on a piece of glass. Its subject is mainly the life behind the glass. The refraction of light diffuses and blurs objects, producing a mottled colouration and a florid yet fragmented feeling. I'm interested in 'vanishing' because its process contains a projection of time. And, by portraying this process, I can recall the disappearing and the disappeared around me and try to record and save them in my own way.

Biography

Zheng Jiang was born in Jingyun, Zhejiang in 1980. He graduated from the Third Workshop, Oil Painting Department, China Central Academy of Fine Arts 2007 (Masters degree there, 2010). Exhibitions include *Time* Joint Exhibition of Zhengjiang and Fu Yingying Art Link Art Hong Kong 2010, *All in the Game: The 7th Annual Exhibition of Dissertation Works in Painting from National Art Academies across China* He Xiangning Art Museum Shenzhen 2010, *Say Hi To The Future* Hi Art 5th Anniversary Exhibition Beijing 2011, *Merry-Go-Round: The 3rd Chinese New Painting Award* Times Art Museum Beijing 2011, *Face* Minsheng Art Museum Shanghai 2012, *Anamnesis* Mizuma & One Gallery Beijing 2012.

Zheng Jiang

胡文龙
Hu Wenlong

失语
Aphasia

2010
Oil on canvas
249 x 167 cm

'Aphasia' (an impairment of language ability) describes my personal and muddled feelings towards oil painting. When I was in middle school, I was deeply attracted to the oil paintings of Chuck Close and to Richard Estes' super realism, even though I knew very little at that time about what oil painting was.

I put a lot of hope and effort into this painting. I want it to be closer to reality - not just the reality within the painting but also my actual feelings about life, especially in this 'so busy, can't stop' era. Aphasia has been haunting me since my adolescence. It disturbs me all the time but I just can't get rid of it. But now, with a deeper understanding of the world I'm living in, I have finally realised that Aphasia is nothing to me, compared with all the things in society that can render you speechless.

Biography

Hu Wenlong was born in Zhucheng, Chandong in 1986. He studied at the Minzu University of China 2007-11.

Hu Wenlong

蒲英玮
Pu Yingwei

腴
Desire

2011
Oil on canvas
200 x 200 cm

The body is the last property of the individual. Even the poorest tramp has his own body, over which he can exercise control. But for a long time, people have connected birth and death with 'life' and not with the 'body' as such. The body has been demoted within the concept of humanity, becoming a completely neutral word. You could say that the notion of the body has been obscured by the meanings and concepts applied on its behalf. Yet, the body is where life exists. Only in the body do life and all of the associated meanings of life exist. Based on this idea, I started making my work about the history of the body, the body-politic of life, and the transformation of post-modern physiology, trying to explore the body's different states within current society and in history. *Desire* is an attempt to analyse and examine myself through the body. It expresses the silent state to be found within lust, hope and reality.

Biography

Pu Yingwei was born in Taiyuan, Shanxi in 1989. He studied at Sichuan Fine Arts Institute Chongqing 2009-12. Exhibitions/projects include *New Make-up* completed with students and teachers from Bashu Experiment School 2010, *Community Lights Life* project Cultural and Education Section British Embassy 2010, *Daily Rent Goods* Old Street No.1 Gallery Chongqing 2011, *Autonomy Case* Organhaus Art Space Chongqing 2011, *Where Are We From And Where Do We Go?* The 18th Oil Painting Department Annual Photograph Exhibition Chongqing 2011, *We are Facing the Bleak Prosperity* Second Prize of the Blogger Cup Chongqing 2011, *'Tranquil', 'Tear', '3:20 p.m.'* Second Award in the *Difference of Latitude* Oil Painting Annual Exhibition Chongqing 2012.

Pu Yingwei

John Moores Painting Prize previous first prizewinners

1957
Jack Smith
Creation and Crucifixion

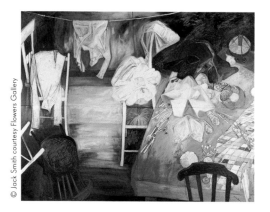

1961
Henry Mundy
Cluster
Bristol Museum & Art Gallery

1959
Patrick Heron
Black Painting - Red, Brown, Olive :
July 1959
*Private Collection, courtesy of
Offer Waterman & Co*

1963
Roger Hilton
March 1963

Unless otherwise stated, these artworks are now part of the
Walker Art Gallery's collection.

1965
Michael Tyzack
Alesso B

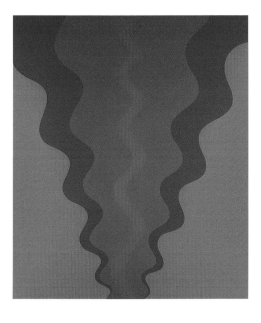

1969 (joint winner)
Mary Martin
Cross

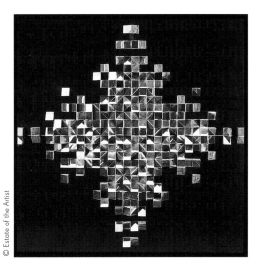

© Estate of the Artist

1967
David Hockney
Peter Getting Out of Nick's Pool

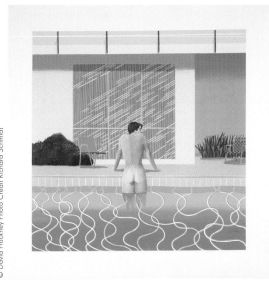

© David Hockney Photo Credit Richard Schmidt

1969 (joint winner)
Richard Hamilton
Toaster
Private collection

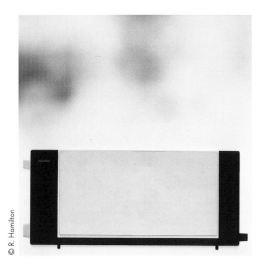

© R. Hamilton

1974
Myles Murphy
Figure Against a Yellow Foreground
Tate

© Myles Murphy

1972
Euan Uglow
Nude, 12 regular vertical positions
from the eye
*University of Liverpool Victoria Gallery
and Museum Collection*

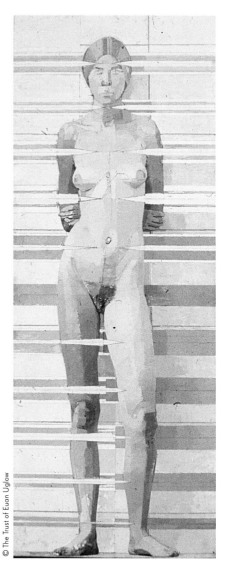

© The Trust of Euan Uglow

1976
John Walker
"Juggernaut with Plume - for P. Neruda"
Collection of the artist

1978
Noel Forster
A Painting in Six Stages with a Blue Triangle

1980
Mick Moon
Box Room

1982
John Hoyland
Broken Bride

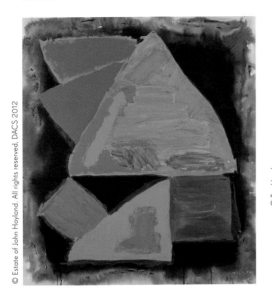

1987
Tim Head
Cow Mutations

1985
Bruce McLean
Oriental Garden

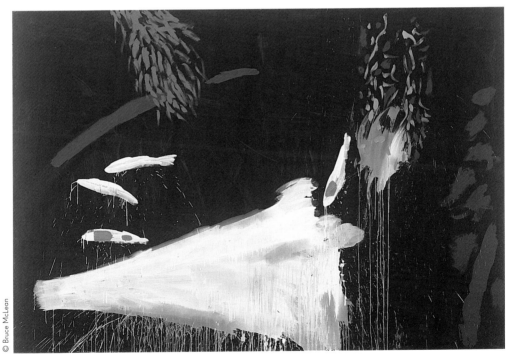

190

1989
Lisa Milroy
Handles

1993
Peter Doig
Blotter

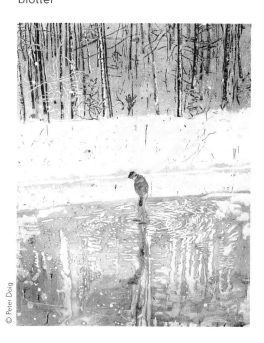

1991
Andrzej Jackowski
Beekeeper's Son

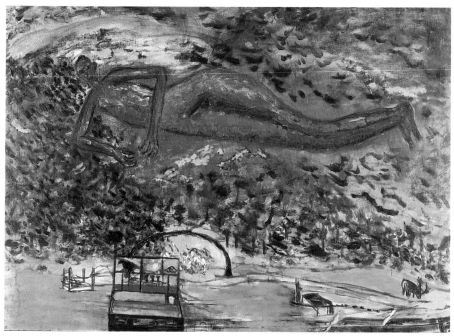

1995
David Leapman
Double Tongued Knowability

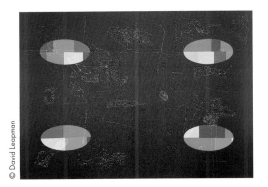

© David Leapman

2002
Peter Davies
Super Star Fucker

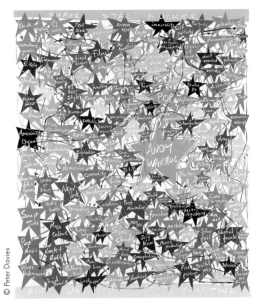

© Peter Davies

1997
Dan Hays
Harmony in Green

© Dan Hays

1999
Michael Raedecker
Mirage

Courtesy of the artist and Hauser & Wirth

2004
Alexis Harding
Slump/Fear (orange/black)

2006
Martin Greenland
Before Vermeer's Clouds

2008
Peter McDonald
Fontana

2010
Keith Coventry
Spectrum Jesus

Courtesy Keith Coventry

This catalogue accompanies the
John Moores Painting Prize 2012
15 September 2012 – 6 January 2013
Walker Art Gallery
William Brown Street
Liverpool L3 8EL

www.liverpoolmuseums.org.uk/johnmoores

Photography: David Flower
Design: Richard Sunderland
Editor: Ann Bukantas
Project Manager (John Moores Painting Prize): Angela Samata
National Museums Liverpool 2012

Catalogue in publication data available
ISBN: 978-1-902700-46-5

A PARTNERSHIP BETWEEN NATIONAL MUSEUMS LIVERPOOL AND
THE JOHN MOORES LIVERPOOL EXHIBITION TRUST

**Liverpool
Biennial
2012**

Prize Sponsor

DAVID·M·ROBINSON
~ FINE JEWELLERY & WATCHES ~

Visitors' Choice Sponsor

RATHBONES
Established 1742

SUPPORTED BY NATIONAL MUSEUMS LIVERPOOL'S CORPORATE MEMBERS SCHEME